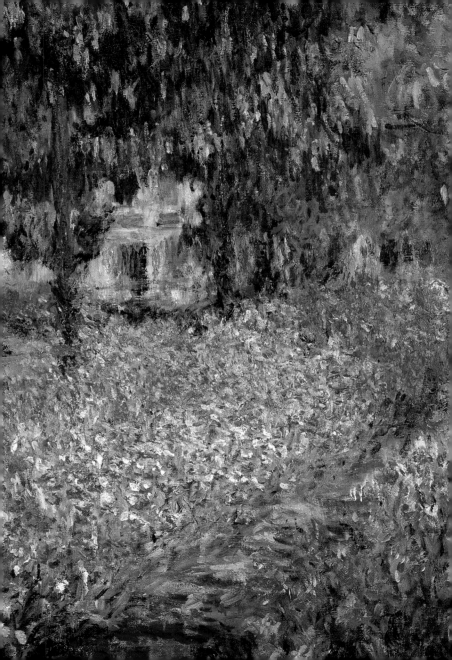

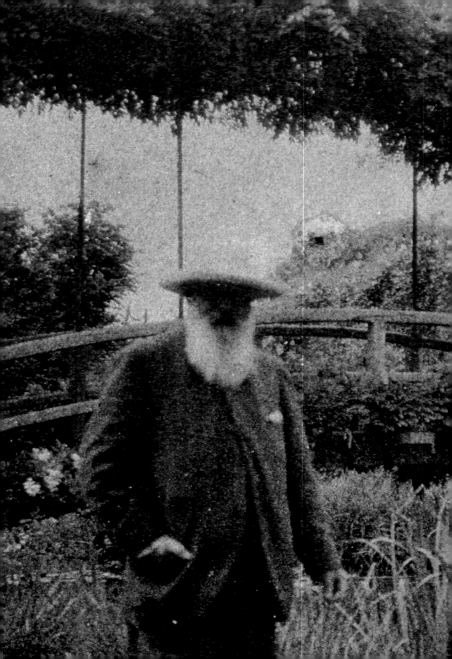

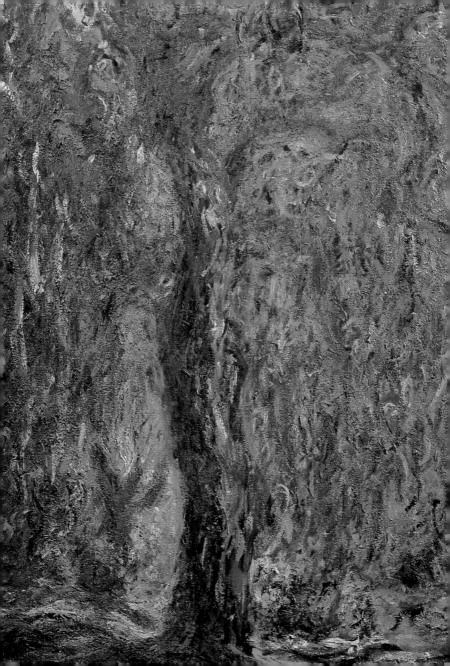

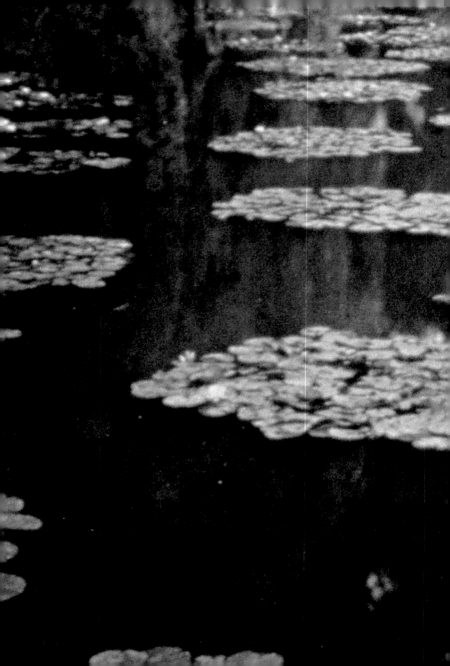

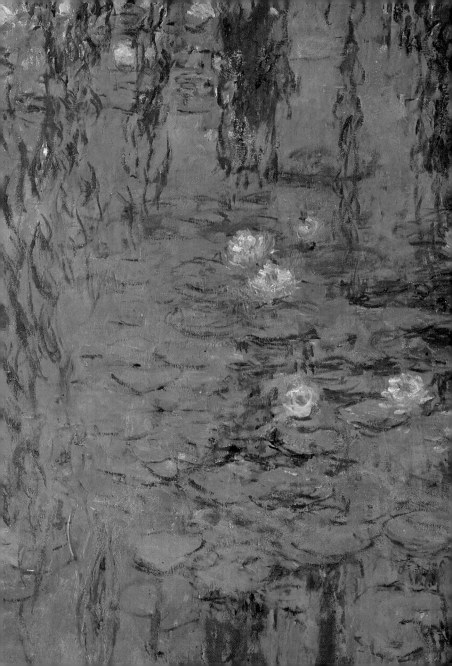

CONTENTS

MONET
THE ULTIMATE IMPRESSIONIST

Sylvie Patin

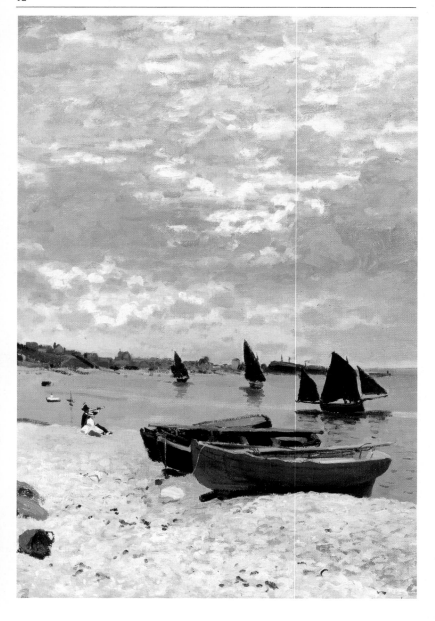

"**A** new name must be recorded here. We were not previously acquainted with Monsieur Claude Monet; a taste for harmonious colouring, ... a bold way of seeing things and of capturing the observer's attention, these qualities Monsieur Monet already possesses to a high degree. We shall not forget him."

Paul Mantz, 'The Salon of 1865'

CHAPTER 1

"IF I HAVE INDEED BECOME A PAINTER, I OWE IT TO EUGÈNE BOUDIN"

At the 1865 Salon, Monet's canvases were entitled *The Pointe de la Hève at Low Tide* and *The Mouth of the Seine at Honfleur.* Two years later the artist was still painting yachts and the sea in *The Beach at Sainte-Adresse* (detail, left). Monet *c.* 1860 (right).

On 14 November 1840 a second son was born to Adolphe and Louise-Justine Monet of 45 Rue Laffitte, in the 9th arrondissement of Paris. Both parents were second-generation Parisians; they had the baby christened Oscar-Claude at the church of Notre-Dame-de-Lorette, and called him Oscar for short. Oscar's early years were permeated with music, on account of his mother's talent as a singer. No one has managed to ascertain what his father did, though he may have been in business.

Monet was born in Paris but his childhood and youth were spent at Le Havre. His first 'impressions' were of boats and the sea.

His precocious talent first emerged in caricatures of Le Havre citizens.

Towards 1845 Adolphe Monet moved to Le Havre with his wife, his children and his own parents, probably encouraged to do so by his half-sister Marie-Jeanne Lecadre, who was married to a wholesale grocer. The latter took Adolphe into his business. Marie-Jeanne, Oscar's aunt, was to prove a kindly influence on him during his adolescence.

On 1 April 1851 Oscar Monet entered the Le Havre secondary school. 'I was born unruly', he admitted later. 'I could never bend to any rule, even as a very small child ... the school always seemed to me like a prison, and I could never resign myself to living there even for the space of four hours a day.' In the school records he appears as 'a very good-natured boy, who gets on well with his fellow pupils'.

Oscar was already producing caricatures for his own amusement, but at the same time was receiving drawing lessons from Jean-François Ochard, a former pupil of Jacques-Louis David (1748–1825), Napoleon's court painter. The boy's first efforts (some dated 1857) are cartoon portraits of individuals, along with sketches of boats and landscapes that already reveal his taste for the open air, 'when the sun was inviting, the sea beautiful and it was so good to run along the cliffs'.

1857: First changes

On 28 January 1857 Oscar's mother died. Being now sixteen, he left school. His aunt Marie-Jeanne, left widowed and childless in 1858, took her nephew into her home. A painter herself, and friend of the painter Amand Gautier, she encouraged Monet to continue his drawing lessons.

Oscar began to sell his caricatures, signed 'O. Monet', at a stationer, framer and ironmonger's shop, where they were displayed alongside the paintings of one Eugène Boudin, a former partner of the storekeeper. 'It was at the framer's that I often exhibited my caricatures, and they earned me a certain notoriety in Le Havre and even a little cash', Monet was to tell G. Jean-Aubry in 1922. 'I also found Eugène Boudin there, who, at the age of about thirty, was beginning to make his presence felt.... at Boudin's suggestion I agreed to go out and work with him in the open air: I bought a box of paints and we went off to Rouelles [north-east of Le Havre] Boudin put up his easel and set to work ... for me it was like the rending of a veil; I understood, I grasped what painting could be ... my destiny as a painter opened up before me. If I have indeed become a painter, I owe it to Eugène Boudin ... with infinite kindness, he set about my education. Gradually my eyes were opened,

"I garlanded the margins of my textbooks, decorated the blue paper of my exercise books, with fantastical ornamentation, and drew the faces and profiles of my teachers, deforming them as much as I could."
Letter to François Thiébault-Sisson, 1900

and I understood nature; at the same time I learned to love her.' The result of these lessons was *Landscape at Rouelles,* a work in the style of Boudin, which was shown at the Le Havre municipal exhibition in August and September 1858.

Paris: Troyon and the Académie Suisse

Adolphe Monet applied to the city of Le Havre for a grant to enable his son to study painting in Paris, but was refused. So it was with the unaided support of his father – encouraged, no doubt, by his aunt – that Monet left for the capital in April 1859. He paid his first calls to the painters Amand Gautier and Constant Troyon; the latter gave him valuable advice. 'Start off by entering a studio where they do nothing but figurative work, studies from the nude: learn to draw ... but don't neglect painting ... then do a few copies at the Louvre. Come and see me often: show me your work.' At the official 1859 Salon, Monet saw the work of Troyon himself, as well as of the painters Charles-François Daubigny, Jean-Baptiste Camille Corot, Eugène Delacroix and Théodore Rousseau. He made an appeal to Boudin that presaged his own lifelong fascination with the sea. 'There isn't one halfway decent seascape to be seen. [Jean-Baptiste] Isabey's is horrible ... the fact is, there are simply no seascape painters, and you could go far in that line' (3 June). Monet was then working at the Académie Suisse, where he first met Camille Pissarro.

The Algerian experience

At the Salon, Monet noticed 'a mass of magnificent paintings of the Orient; in all of them there is a certain grandeur, and a warm light' (letter to Boudin, 3 June 1859). This admiration may partly explain the young man's voluntary enlistment in the first

A drawing made in *c.* 1856 of the semaphore and the François Premier tower at the entrance to the port of Le Havre.

A sketch by Monet, *c.* 1857, showing Boudin drawing in the open air (left).

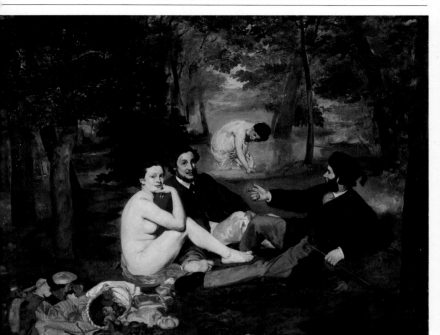

where they stayed at the Auberge Saint-Siméon – a popular artists' haunt. Monet remained at Honfleur after Bazille's departure, writing to him enthusiastically on 15 July: 'It's lovely here, my dear friend; every day I discover more and more beautiful things. It's enough to drive me mad, I want to paint everything so badly … I have some wonderful projects.'

At the end of that year Monet returned to Paris, where Bazille invited him to come and work in his studio at 6 Rue de Furstenberg. In 1865 the jury of the Salon accepted two landscapes of the 'Le Havre painter', his first official taste of success, and he was mentioned by the critic Paul Mantz in the *Gazette des Beaux-Arts* (July 1865).

Spring 1865 saw Monet back at Chailly. 'The countryside is admirable', he wrote to Bazille. 'Come as soon as you can.' In the first days of May he told his friend of his plan to paint an immense composition

Manet's *Déjeuner sur l'herbe* was shown at the Salon des Refusés in 1863. Though it is traditional in inspiration – based on the pastoral and bacchanalian scenes of classical masters, with touches of Titian, Giorgione and Raphael) – the most striking element of this 'modern' composition is Manet's juxtaposition of a female nude with fully dressed men. Two years later Monet produced a painting of the same subject in a completely different style.

(nearly 4 x 6 metres), entitled *The Picnic*. 'I want you to be here very much. I would like your opinion on the choice of landscape for my figures.' That summer, he wrote again: 'You promised to help me with my picture, you must come and pose for some of the figures. If you don't, the picture will be a failure; so I hope you will keep your promise.' Monet worked on the preparatory sketches at Chailly and set about the painting in his Paris studio during the autumn. 'I began just as everybody did then, by taking sketches from nature and composing the ensemble in my studio' (letter to the Duke of Treviso, 1920). But the work remained unfinished; Monet probably gave up his idea of exhibiting this youthful masterpiece at the 1866 Salon after the painter Gustave Courbet himself came to see it and criticized it. Indeed, the large format (inspired by Courbet's *grandes machines*) was not representative of true open-air landscape painting: the future lay with canvases that could be done on the spot.

'I think of nothing but my picture, and if I knew I was failing with it, I think I'd go mad', wrote Monet to Bazille of *The Picnic*, which he began in 1865. Only two large fragments of it survive (below). The smaller preparatory sketch (right) gives a general idea of the huge original composition. Below, a pencil sketch.

Ordinary everyday figures, lifesize, are pictured in the luminous atmosphere of a sunny glade. The scene, rendered almost as in a photograph, is apparently captured on the instant. Bazille posed for several of the figures; the bearded man sitting in front of the magnificent still life in the foreground may be Courbet.

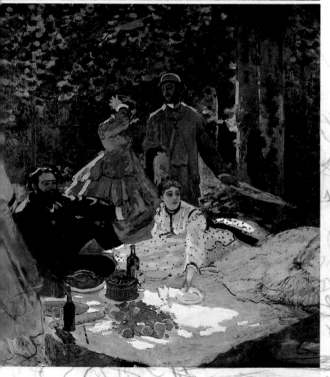

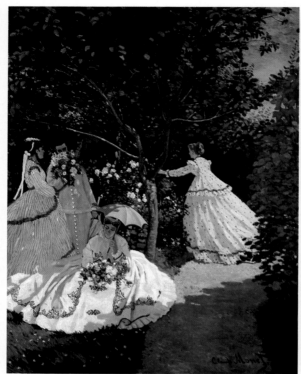

Woman in a Green Dress (Camille)

Monet was soon back at work, preparing paintings for the 1866 Salon. After he and Bazille left the Rue de Furstenberg studio, he painted his lifesize figure *Woman in a Green Dress*. His model, the young Camille Doncieux, was to become the first Madame Monet. The painting was shown under the title *Camille*, together with a landscape of Chailly; it was noticed by the critics, some of whom made play with the names 'Manet' and 'Monet'. The journalist Zacharie Astruc responded by bringing the two men together face to face, so as to avoid any bad feeling between them.

After *Woman in a Green Dress*, which was painted indoors, Monet was eager to make another attempt at figures in a landscape.

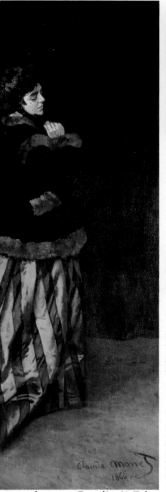

'I retreated to a little house near Ville d'Avray'

The artist next installed himself at Sèvres. 'I am happier than ever', he wrote to Amand Gautier on 22 May. 'I have made up my mind to retreat to the country; I am working a lot, and my courage is higher than ever. My success at the Salon secured me several picture sales.' Soon he was having a trench dug in his garden so that he could work on the upper areas of a huge new canvas, *Women in the Garden,* by lowering it into the trench. This painting was taken to Honfleur, where he spent the summer and part of the winter. The painter Alexandre-Louis Dubourg mentions it in a letter to Boudin (2 February 1867) from the little Norman seaport: 'Monet is still here, working away at enormous pictures ... he has one which is nearly three metres high and just as wide. The figures are slightly less than lifesize, women in full summer dresses picking flowers in a garden. It's a canvas that he started in the open air.'

Camille, Monet's mistress, again served as a model for *Women in the Garden* (1866–7, opposite page), in which she is the figure standing at far left, recognizable by the lock of hair in front of her ear. This painting was rejected by the 1867 Salon, but Zola remembered it a year later.

"A painting of figures, women in light-coloured summer dresses picking flowers along a garden walk; the sun falling straight on their skirts, which are brilliantly white; the warm shadow of a tree cutting across the path and their clothes like a broad grey blanket. Nothing could be stranger than this effect."

Emile Zola
L'Evénement illustré
24 May 1868

In the first months of 1867 Monet joined Bazille at 20 Rue Visconti in Paris, where Renoir was also living. That spring, Monet and Renoir worked on views of the city. Turned down by the jury of the 1867 Salon, *Women in the Garden* was bought by Bazille in January 1868 for the sum of 2500 francs, which he paid to his friend by instalments of 50 francs per month.

'I am with the family, and as well as I can be'

'People are kind to me, they admire my every brushstroke', wrote Monet to Bazille from Sainte-Adresse. 'I have laboured very hard, too: I have a score of paintings well under way, stunning seascapes, figures, gardens – everything, in fact.' Among other things, he was working on *The Terrace at Sainte-Adresse* – a foretaste of Impressionism.

At this time Monet's letters reveal 'the deepest concern about Camille', whom he had left alone and pregnant in

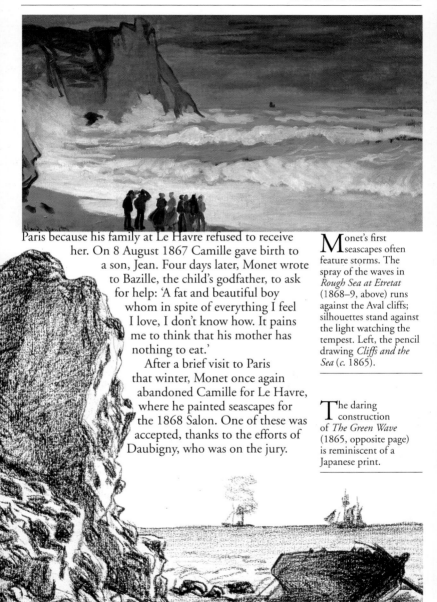

Paris because his family at Le Havre refused to receive her. On 8 August 1867 Camille gave birth to a son, Jean. Four days later, Monet wrote to Bazille, the child's godfather, to ask for help: 'A fat and beautiful boy whom in spite of everything I feel I love, I don't know how. It pains me to think that his mother has nothing to eat.'

After a brief visit to Paris that winter, Monet once again abandoned Camille for Le Havre, where he painted seascapes for the 1868 Salon. One of these was accepted, thanks to the efforts of Daubigny, who was on the jury.

Monet's first seascapes often feature storms. The spray of the waves in *Rough Sea at Etretat* (1868–9, above) runs against the Aval cliffs; silhouettes stand against the light watching the tempest. Left, the pencil drawing *Cliffs and the Sea* (*c.* 1865).

The daring construction of *The Green Wave* (1865, opposite page) is reminiscent of a Japanese print.

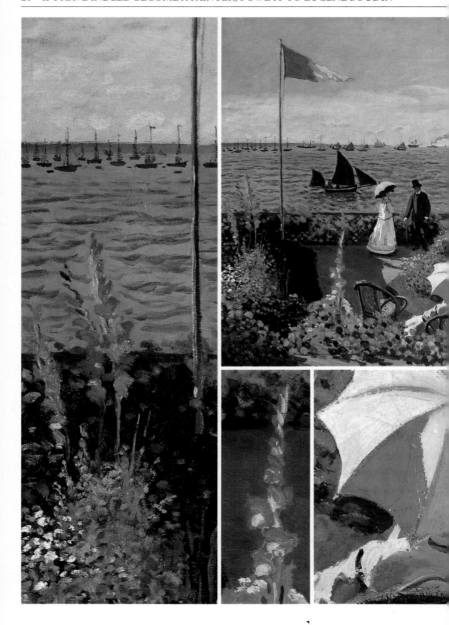

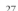

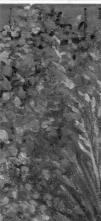

Bathed in sunlight under fluttering flags, *The Terrace at Sainte-Adresse* (1867) shows the artist's family; his father (seated), perhaps his aunt Lecadre, and at centre his distant cousin Jeanne-Marguerite Lecadre with an unidentified man. Here Monet captures the feel of the coast, where the intense sunshine flattens forms instead of rounding them out. The accessories help to illustrate life by the sea in summertime; the light-coloured clothes of the women, the straw hats, the wicker chairs. The yachts, one of which stands out in the middle ground, go by on a blue-green sea, while farther out and on the horizon are steamships and all kinds of other vessels. This resplendent vision of a moment of happiness, in which flowers contrast with the water in a play of light and shadow, skilfully demonstrates the link between Monet's favourite motifs: 'stunning seascapes and figures and gardens' (letter to Bazille from Sainte-Adresse, 25 June 1867).

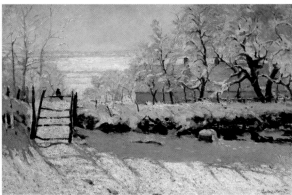

Between Le Havre, Etretat and Paris

"I am going into the country, which is so lovely now that I almost like it better in winter than in summer."
Letter to Bazille, Etretat
December 1868

This spectacular 'snow effect' seems to take up a special challenge: how to use different shades of white to express the density and luminosity of a winter landscape, in which the black *Magpie* stands in sharp contrast (at left, with details below left and at right).

Probably on the recommendation of his friend Emile Zola, the novelist, Monet spent the spring of 1868 at the Auberge de Glotin, at Bennecourt near Bonnières-sur-Seine, with Camille and Jean. On 29

June he wrote to Bazille: 'I'm leaving for Le Havre this evening, to see if I can get my art-lover to commission something ... my family refuse to do any more for me.' Monet's 'art-lover' was Louis-Joachim Gaudibert, an industrialist who commissioned him to paint a portrait of his wife.

At Le Havre Monet showed five paintings at the 'International Maritime Exhibition', in which Antoine Vollon, Corot, Courbet and Boudin also participated. The exhibition jury, one of whose members was Monet's old teacher Ochard, awarded him the silver medal. Also at this time Courbet introduced him to the novelist Alexandre Dumas.

In August Camille and Jean moved to Fécamp, still well away from the Monet family. Monet's

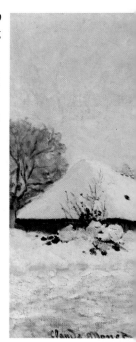

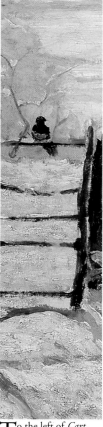

pleas for money in his letters to Bazille begin to sound more urgent and more emotional: 'Consider my position. I have a sick child and no money whatever' (6 August 1868). In spite of his exhibition success, he continues to complain: 'My painting isn't working at all, I no longer expect fame Everything looks black. On top of it all, there is still no money. Disappointments, affronts, hopes, more disappointments – there you have it, my friend' (letter to Bazille, October/November 1868). But in December, at Etretat, the old ardour seems to have returned. 'Here I am surrounded by everything I love. In the evening, my dear friend, I come back to my little house where there is a good fire and a good little family. If you could only see your godson, how sweet he is at present. My friend, it's quite lovely to watch the little creature grow, and God knows I am happy to have him. I plan to paint him for the Salon.' This happy interlude is commemorated by views of Etretat and by

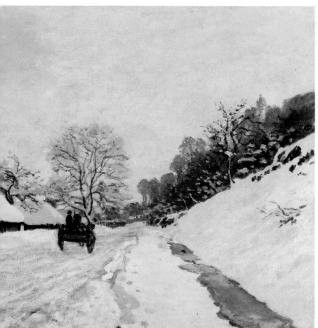

To the left of *Cart, Road under Snow, Honfleur* (left, *c.* 1867) is the roof of a farmhouse where the painters used to meet: 'I am still at Saint-Siméon, we are so happy here ... we form a very agreeable little circle' (letter to Bazille, 26 August 1864).

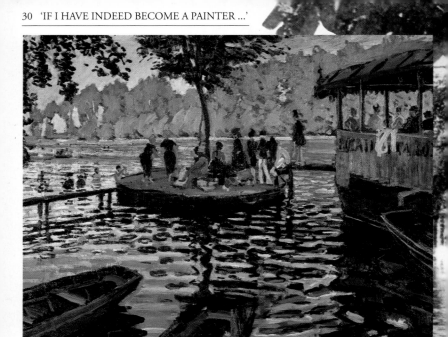

Monet's celebrated snowscape, *The Magpie*. Nevertheless, his work was yet again turned down by the 1869 Salon.

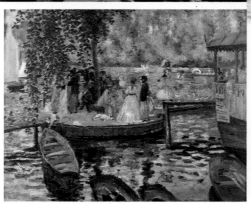

'A work of art that has no public recognition'

June 1869 saw Monet living at the hamlet of Saint-Michel, near Bougival on the Seine. 'Conditions are very good here', he wrote to Arsène Houssaye, the director of the magazine *L'Artiste*, who had bought his *Green Woman* (Monet's nickname for *Camille*). 'I have plenty of energy for work, but alas that fatal rejection has taken the bread from my mouth; despite my low prices, dealers and buyers turn their backs. It's sad how little people are interested in a work

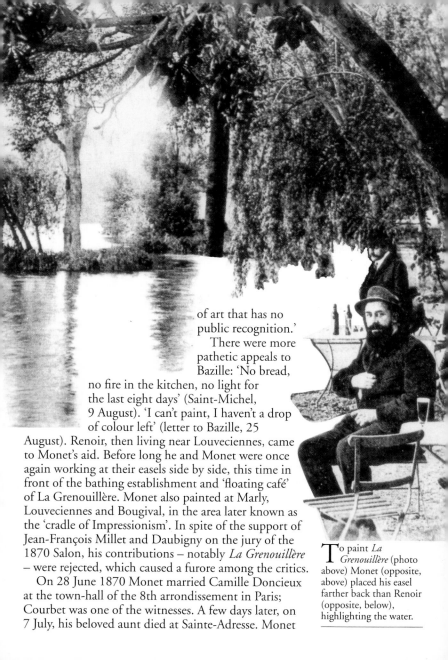

of art that has no public recognition.'

There were more pathetic appeals to Bazille: 'No bread, no fire in the kitchen, no light for the last eight days' (Saint-Michel, 9 August). 'I can't paint, I haven't a drop of colour left' (letter to Bazille, 25 August). Renoir, then living near Louveciennes, came to Monet's aid. Before long he and Monet were once again working at their easels side by side, this time in front of the bathing establishment and 'floating café' of La Grenouillère. Monet also painted at Marly, Louveciennes and Bougival, in the area later known as the 'cradle of Impressionism'. In spite of the support of Jean-François Millet and Daubigny on the jury of the 1870 Salon, his contributions – notably *La Grenouillère* – were rejected, which caused a furore among the critics.

On 28 June 1870 Monet married Camille Doncieux at the town-hall of the 8th arrondissement in Paris; Courbet was one of the witnesses. A few days later, on 7 July, his beloved aunt died at Sainte-Adresse. Monet

To paint *La Grenouillère* (photo above) Monet (opposite, above) placed his easel farther back than Renoir (opposite, below), highlighting the water.

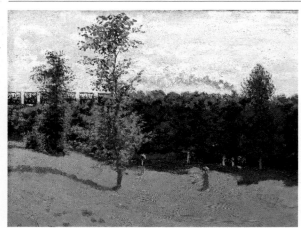

spent that summer at Trouville in Normandy, where he worked on the beach and painted the *Hôtel des Roches Noires*. It was here that he heard of the declaration of war between France and Prussia. On 18 November Bazille was killed on the battlefield of Beaune-la-Rolande. To avoid conscription Monet determined to escape by boat to England, where Camille and Jean later joined him.

'This is a man who will be greater than any of us. Buy his work'

It was with these words that Daubigny introduced Monet to the dealer who was to be the Impressionists' most loyal supporter: Paul Durand-Ruel. Their meeting was an event of great importance. A Monet canvas was

The railway allowed people to leave the capital for a few hours and take the air in the countryside. The double-decker coaches outlined against the sky in *Train in the Countryside* (*c.* 1870, left, detail below) were used on the line from Paris to Saint-Germain-en-Laye.

"In the country, Claude Monet would seem to prefer an English park to a woodland glade. He takes pleasure in finding traces of mankind everywhere he goes, he wishes at all times to live among us. Like a true Parisian, he takes Paris to the country with him; he is unable to paint a landscape without including gentlemen and ladies in long dresses. Nature seems to lose her interest for him when she bears no imprint of our habits."
Emile Zola
L'Evénement Illustré
24 May 1868

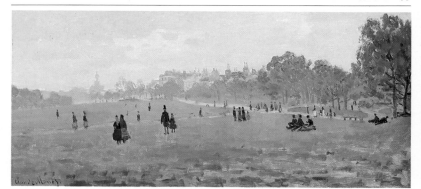

shown at the first Durand-Ruel exhibition in London in December 1870. The following year, the dealer began buying Monet's canvases in quantity.

With Pissarro, who was also in London, Monet visited the capital's museums, taking a particular interest in the English landscape artists (John Constable and especially J.M.W. Turner). Both Monet and Pissarro exhibited their work at the 'International Fine Arts Exhibition' which opened in Kensington on 1 May 1871.

Monet returned to France by way of Holland. 'What I have seen is much more beautiful than people say', he wrote to Pissarro from Zaandam (2 June 1871). Inspired by the houses, mills and barges of the Low Countries, he wrote again on 17 June 'I am starting to work feverishly and have hardly any time to spare.' As in London, he visited the museums, notably Amsterdam's Rijksmuseum. In the autumn, he arrived back in Paris.

During his first visit to London, Monet produced a few canvases of public gardens, such as *Green Park* (above). The lengthened format of the composition, which is handled like a sketch with small dark figures, evokes the huge expanses of green that characterize London's parks. On the same visit he painted his beautiful *The Houses of Parliament and the Thames*.

"We often see Monet, and went to his housewarming recently. He is very well established and seems to have a strong desire to carve out a place for himself. I think he is destined to take one of the leading positions in our school."

Eugène Boudin, 2 January 1872

CHAPTER 2

ARGENTEUIL, THE HIGH NOON OF IMPRESSIONISM

In fields of burning red *Poppies* (1873, detail left) Camille Monet and her son Jean are seen walking. This landscape of the sunlit country around Argenteuil was one of the canvases that represented the artist's work at the First Impressionist Exhibition in 1874. Monet, aged about twenty-eight (right).

 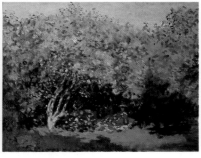

'Maison Aubry, near the almshouse at Porte Saint-Denis, Argenteuil'

This was the address Monet passed on to Pissarro on 21 December 1871, with the remark that 'we are very busy moving in just now'. The house (probably chosen for him by Manet) was close to the River Seine, always a rich source of subject matter for Monet. He was greatly interested in the yachts, tugs, the famous Argenteuil pool with its promenade, as well as the railway bridge and toll-bridge, which were under reconstruction following the war of 1870.

Monet continued to paint flowers and to work in his garden. Throughout the spring of 1872 he explored ways of representing human figures in landscapes, more often than not using Camille and Jean as models. While at Sainte-Adresse he had painted the Lecadre family from two different angles (*The Garden in Flower* and *Jeanne-Marguerite Lecadre in the Garden*); but here in Argenteuil he twice took the same corner of the garden (a clump of lilacs) for his subject, depicting it in different lights. These two paintings are the earliest forerunners of Monet's 'serial' treatment, which was to be so much a feature of his work in the 1890s. Apart from the Seine and his own garden, Monet amused himself painting the countryside around Argenteuil and the hills of the Sannois district.

'Monet seems happy with his lot, despite the difficulty he has in getting his paintings accepted', commented

*L*ilacs in Dull Weather (above left, with detail below) and *Lilacs in Sunshine* (above) of spring 1872: these represent Monet's first attempt at depicting a single subject under different lights.

"His landscapes are illumined by the sun ... among others, there is a painting of a woman in white, seated in leafy shadows, whose dress is sprinkled with droplets of pure light."
Emile Zola
Le Messager de l'Europe
June 1876

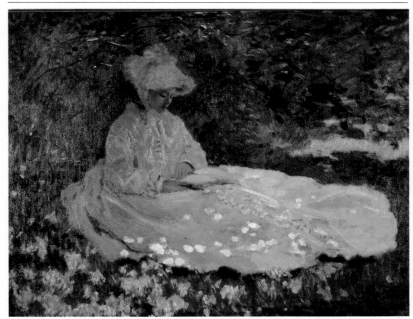

Boudin on 12 December 1872. All in all, it had been a productive year for the young artist, in terms of both work and money. He had sold thirty-eight canvases; one to his brother Léon, one to Manet, five to the dealer Louis Latouche and above all twenty-nine to Durand-Ruel, for a total sum of 12,100 francs. This information is provided by Monet's account book which, together with Durand-Ruel's register, constitutes a vital source of information about him.

The next year saw Monet's profits from his work double. The average price for one of his paintings increased to 750 francs; and again Durand-Ruel was a major purchaser. The first generation of Monet-fanciers

Monet continued his exploration of the human figure in a landscape with a *Girl Reading* (*c.* 1872–4), for which his model was probably Camille. The sketch-like handling of this picture lends it the force of a first impression; it delighted Zola when he saw it at the 1876 Second Impressionist Exhibition.

SOCIÉTÉ ANONYME
DES ARTISTES PEINTRES, SCULPTEURS, GRAVEURS, ETC.

included the banking brothers Albert and Henri Hecht, and the critic Théodore Duret, author of *The Impressionist Painters*, a pamphlet that appeared in 1878. With the confidence born of this success, Monet soon began to drive much harder bargains.

In 1873 Monet returned to Normandy where he painted views of Etretat, Sainte-Adresse and the port of Le Havre. Although it is dated '72', the canvas that has become immortal under the title *Impression, Sunrise* in fact belongs to this period.

1874: The First Impressionist Exhibition

Having absorbed the lesson of his rejections by the Salons of 1869 and 1870, Monet now gave up trying to convince the jury, as did Pissarro and Sisley. The idea of organizing an exhibition independent of the Salon had first been mooted by Monet, Bazille and their friends in 1867, but was dropped for lack of funds. It now re-emerged: 'Everyone thinks it a good thing, only Manet is against it', wrote Monet to Pissarro on 22 April 1873. In a letter to the playwright and art critic Paul Alexis dated 7 May, Monet referred to the 'Company we are presently forming' and on 30 November he informed Pissarro 'I have not forgotten our Company, I am doing what I can'. Like Pissarro, Edgar Degas and Renoir, he spared himself no trouble for the cause.

After several reframings of the founding statute (during which Monet appears to have played the role of peacemaker), a 'limited cooperative Company of artist-painters,

> "I sent something I did at Le Havre: the sun in the mist, and a few ships' masts ... they asked me its title for the catalogue and I said: 'Call it *Impression*'."
> Monet, quoted by the journalist Maurice Guillemot in *La Revue illustrée*, 15 March 1898

L'Exposition

'What does this canvas mean? Look at the booklet. *Impression, Sunrise* [right]. *Impression*, just as I thought. I also said to myself, since I'm impressed, there must be some impression in it.' It was in this mocking passage by the critic Louis Leroy in *Le Charivari*, 25 April 1874, that the term 'Impressionism' originated.

. Monsieur le peintre impressionniste
— à la Morgue !

sculptors, engravers etc.', consisting of thirty members, was formed on 17 January 1874. The Company's first exhibition was held from 15 April to 15 May in premises belonging to the photographer Nadar (Félix Tournachon) at 35 Boulevard des Capucines in Paris.

The catalogue included sixty-five items under the names of Boudin, Félix Bracquemond, Paul Cézanne, Edgar Degas, Armand Guillaumin, Edouard Lépine, Berthe Morisot, Pissarro, Renoir and Sisley, to mention only a few. Some of the exhibitors (Astruc, Boudin,

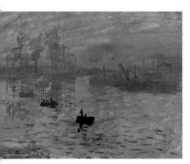

Latouche and Lépine, for example) were also present at the official Salon, which opened a fortnight later. Numbers 95 to 103 in the catalogue were works by Monet (sometimes with two pictures listed under the same number). They included *Poppies*, a seascape of Le Havre, a view of the *Boulevard des Capucines*, the interior scene with Camille and Jean (*Luncheon*, 1868) that had been refused by the 1870 Salon – was this perhaps a defiant challenge to the jury? – and, above all, *Impression, Sunrise*.

The critics lashed out immediately at the rebel group, denouncing the unfinished quality of their technique. In the 25 April issue of *Le Charivari*, Louis Leroy entitled his article 'Exhibition of the Impressionists', while Emile Cardon wrote about the 'School of the Impression' (*La Presse*, 29 April). The more indulgent Armand Silvestre, commenting in *L'Opinion Nationale* on 22 April, allowed himself to be interested in the 'vision of things' displayed by Monet, Pissarro and Sisley; nevertheless, he wrote, 'it is an effect of impression alone that this vision seeks to discover; expression is left to adepts of the line'.

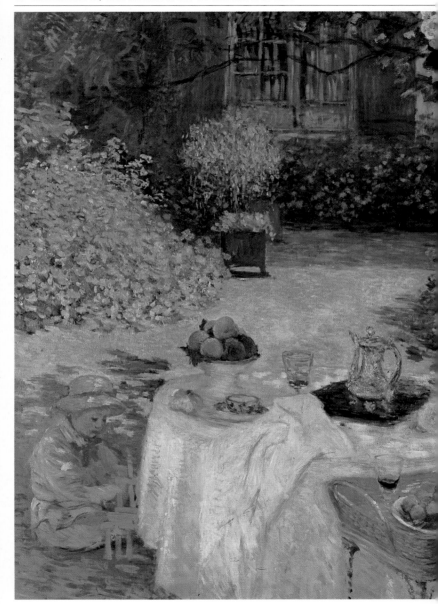

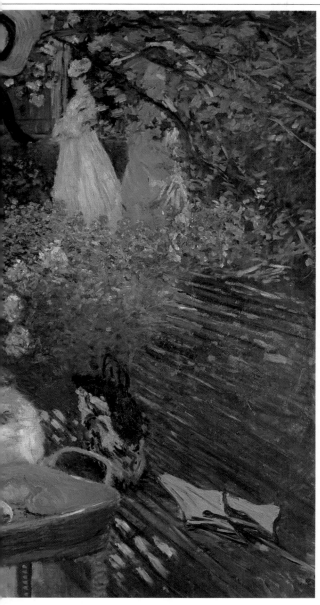

In the garden of Monet's first house at Argenteuil the painter's son Jean sits engrossed with his toys, while in the background are two female figures whose dresses stand out against the foliage. This light-filled canvas, entitled *Luncheon* (*c.* 1873), seems to exude well-being. Anecdotal details combine to express an art of living in the country: the abundance of flowers, the attractiveness of the clothes, the whiteness of the tablecloth, the arrangement of the food (especially the fruit dish) and the refined cups and coffee pot. At the same time there is a certain strangeness about the painting, for the meal is over, and it is precisely this moment that Monet has chosen. The diners have left the table, the parasol lies on the bench and the hat hangs forgotten from a bough of the tree; all this creates an enigmatic atmosphere, as of a happiness that is fleeting. This composition, the format of which is unusual for Monet's Argenteuil period, figured in the 1876 Second Impressionist Exhibition under the title *Decorative Panel.*

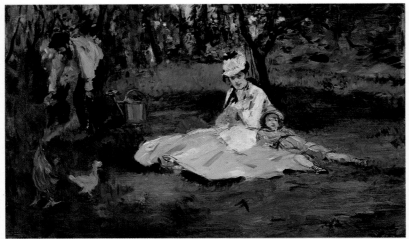

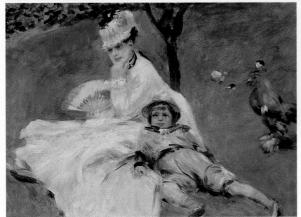

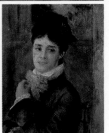

The Company was dissolved in December – but Impressionist exhibitions were fated to resume two years later in 1876.

The halcyon days of Impressionism

After the tension surrounding the exhibition, Monet retired to Argenteuil for a well-deserved rest. His friends were frequent visitors; Manet, who contributed to the household expenses, painted *The Monet Family in the*

Manet recorded his friend's domestic life with *The Monet Family in the Garden* (1874, top), a composition that includes Monet himself, gardening in the background, and in which the lines and colour harmonies are carefully worked out. Renoir's spontaneous version of the same subject shows only Mme Monet and her son (left).

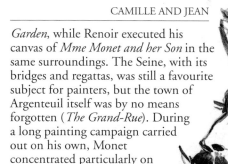

Garden, while Renoir executed his canvas of *Mme Monet and her Son* in the same surroundings. The Seine, with its bridges and regattas, was still a favourite subject for painters, but the town of Argenteuil itself was by no means forgotten (*The Grand-Rue*). During a long painting campaign carried out on his own, Monet concentrated particularly on winter landscapes (*The Train*, or *The Train in the Snow*, 1875).

In the autumn of 1874 the painter moved yet again, to '2 Boulevard Saint-Denis, opposite the station, a pink house with green shutters', a foretaste of his future house at Giverny. The garden appeared in his 1875 work and was to be even more prominent in that of the following year.

The fine spring weather of 1875 also saw Monet on the riverbank at Petit-Gennevilliers and out in the flowering meadows with Camille and Jean.

'Although I have faith in the future, the present is very hard to bear' (letter to Manet, 28 June 1875)

With Durand-Ruel obliged first to cut back, then temporarily suspend his purchases, Monet had to count on new buyers of Impressionist work, whose names now began to appear in his account books. The main ones were the opera baritone Jean-Baptiste Faure and the textile merchant Ernest Hoschedé, a passionate collector who bought *Impression, Sunrise* in May 1874 for the exceptional price of 800 francs. However, Monet's earnings for 1874 (a total of 10,554 francs) were well below those of the previous year.

If Manet's qualities as a colourist are obvious in *The Monet Family*, the painting's linear precision shows that he could also be a great draughtsman. The same talent appears in his China ink wash study of Monet, *Head of a Man* (above). The hat tilted backwards, the incisive, skilful brushwork, and the intensity of the black beard emphasize Monet's forceful profile.

In 1872 Renoir painted intimate portraits of Camille (below right, opposite page) and Claude Monet (at left). Here Monet is caught in an ordinary humdrum pose, smoking his pipe and reading his newspaper.

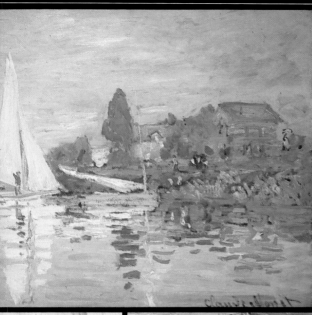

From the river at Argenteuil to the flower garden

In 1874 Manet painted *Monet Painting in his Studio-Boat* (opposite, above). This vessel, which Monet himself depicted several times (opposite, below, *The Studio-Boat, c.* 1874) had been adapted by the artist for his work on the Seine. *Regattas at Argenteuil* (1872) demonstrates Monet's perfect technical mastery. Here touch and colour are fragmented to convey the play of the quivering water surface and the reflected sails.

In *Monet Painting in his Garden at Argenteuil* (overleaf, above right), Renoir portrayed his friend at his easel. Monet's version of the same garden, *The Artist's House at Argenteuil* (overleaf, main picture and details), places Jean in the centre, framed by small urns that heighten the decorative effect of the scene. The child, who is dressed with studied elegance, is a strong presence though seen from behind only. The leaves and flowers, with their blend of greens and reds, are reminiscent of *The Terrace at Sainte-Adresse*, as are the pools of light and shadow on the path.

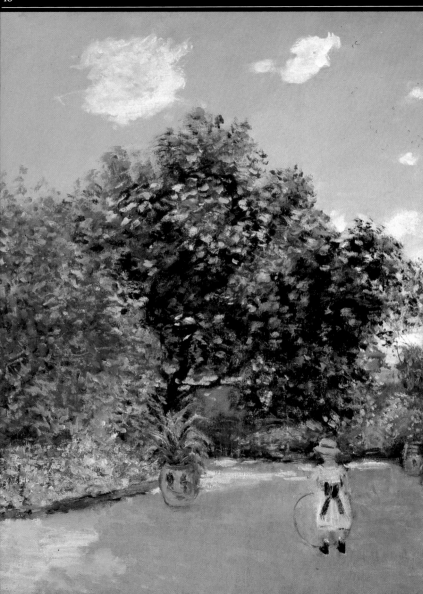

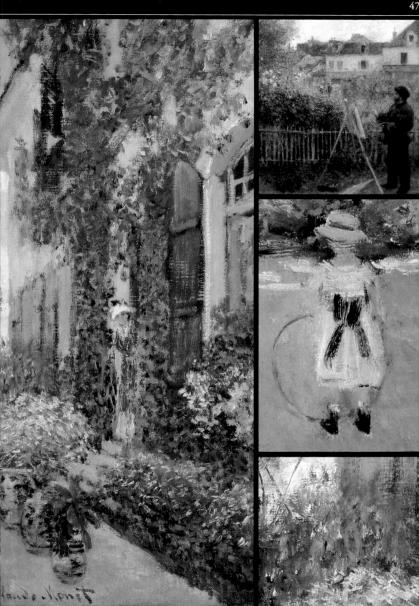

On several occasions in 1875 he applied to Manet for help: 'My colour-box will stay closed for a long time now, if I can't get out of this mess', he wrote. Each time his faithful friend answered the call with cash advances, just as Bazille had done before him.

On 24 March 1875 a sale was arranged (probably by Renoir) at the Drouot auction rooms, with Durand-Ruel as auctioneer; 163 works by Renoir, Morisot, Sisley and Monet went under the hammer for very low prices, amid a torrent of sarcasm. Monet's twenty canvases failed to reach even 200 francs. His income was now very small; but still the circle of buyers (Faure, Emile Blémont, Ernest May, Henri Rouart, Victor Chocquet) who dealt with him on a private basis continued to grow, heralding the recognition of his talent.

A Second Impressionist Exhibition took place in April 1876 at the Durand-Ruel Gallery, 11 Rue Le Peletier in Paris. The catalogue featured eighteen pictures by 'Monnet' (sic). While there were still many prepared to mock, the press greeted this show more favourably than that of 1875.

The writers Armand Silvestre, Jules-Antoine Castagnary and Stéphane Mallarmé were full of praise, and Emile Zola saluted Monet's major role: 'Without a doubt, Claude Monet is the leader of the group. His brush is distinctive for its extraordinary brilliance.' Yet even at this early stage cracks had begun to show in the Impressionist front.

Fresh buyers began to emerge, among them the painter and collector Gustave Caillebotte and the doctor Georges de Bellio. Both became financial and moral mainstays for Monet.

The amenities of Argenteuil became accessible through the growing new system of railways. *The Railway Bridge, Argenteuil* (1874, below, with details) was just as suitable a subject for Monet as gardens and yachts.

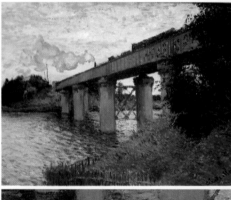

The passage of a train over the bridge, crossing the countryside obliquely, is caught as if in a photograph.

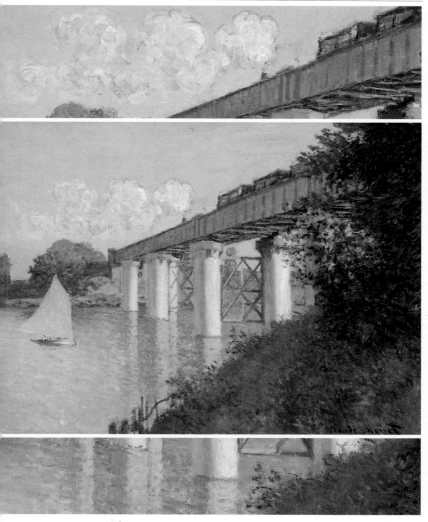

Ernest and Alice Hoschedé at Montgeron

When Monet was scouting for subject matter away from Argenteuil (notably in Paris, during the spring of 1876) Ernest Hoschedé invited him to decorate his Château de

In this version the massive architecture is broken up by the combined action of light and water.

Rottembourg, at Montgeron, which his wife Alice had inherited. In 1875 the collector had to sell his family textile business. The next year, he founded a new company.

A lice Hoschedé, photographed on 1 January 1878 with Jean-Pierre Hoschedé, who was probably Monet's child.

To decorate the main salon of the château, Monet executed four paintings illustrating the two seasons during which he stayed there: the summer, with *Turkeys*, *Corner of a Garden at Montgeron* (or *The Dahlias*), and *The Pool at Montgeron*; and the autumn, with *The Hunt* (or *Avenue in the Park, Montgeron*). It is probable that he saw Gustave Caillebotte, who owned a property near the River Yerres, at this time. On 20 August 1877 Alice Hoschedé gave birth to her sixth child, Jean-Pierre Hoschedé, who is thought to have been Monet's son. At all events, in later life Jean-Pierre liked to refer to his physical resemblance to Monet, about whom he wrote a book.

'We must leave Argenteuil'

After his interlude at Montgeron, Monet returned to Argenteuil and a host of money worries. 'Unless there is a sudden torrent of rich patrons, we are going to be put out of this nice little house ... where I have worked so well ... and yet I was full of enthusiasm and had plenty of projects' (letter to Dr de Bellio, c. 25 July 1876). The first months of 1877 were taken up by a painting of *The Gare Saint-Lazare* and the preparation of the Third Impressionist Exhibition, in which, among other things, Monet showed *Turkeys*.

Life at Argenteuil had involved major expenses; despite the large income recorded in his accounts, the painter was heavily in debt and worried that his furniture would be removed and sold if he failed to satisfy his creditors. To Dr de Bellio he wrote that

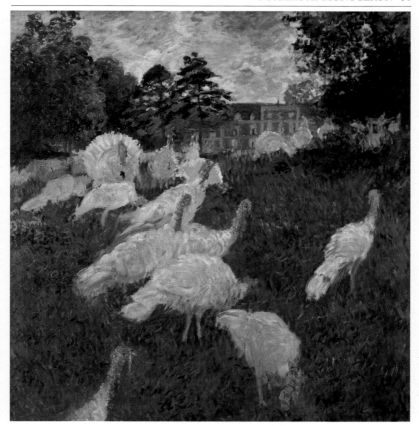

'fresh misfortunes have befallen me; as if it were not enough to be short of money, my wife has now fallen ill.'

On 15 January 1878 he told his friend: 'In two days, that is *the day after tomorrow*, we must leave Argenteuil; and to do that, I must pay my debts.' No doubt it was thanks to a cash advance from Caillebotte that Monet was able to leave Argenteuil. Even so, he had to leave *The Picnic* with his landlord as surety. The fate of this picture, rolled up and stored in a cellar, symbolized the end of an era. Later, Monet insisted on recovering *The Picnic*, which he saw as a link with his youth, and as the most spectacular illustration of his early years as an artist.

In 1876 Monet returned to large-format work with his decorative panels for the Château de Rottembourg, seen here in the background of his *Turkeys*. This is a surprising subject, with a daring perspective borrowed from Japanese prints. The turkey in the foreground adds to the immediacy of the scene.

"Paris! You must go to Paris! Young men, writers and artists who breathe the stifling air of the provinces are obsessed with this idea. Claude Monet ... wanted to be in Paris so he could see the museums and exhibitions, meet other painters, and show his work at the Salon. Later, nearly all of them (and Monet in particular) were glad to regain their solitude ... and draw one or two secrets from the sphinx that is nature."

Gustave Geffroy, *Claude Monet*, 1922

CHAPTER 3

"THIS STUNNING PARIS"

Crowd effects, as in *Rue Montorgueil, Fête of 30 June 1878* (detail at left), were Monet's principal subject matter in Paris. 'This city frightens me', he wrote to Geffroy. Monet *c.* 1875 (right).

'All the beautiful things I see in Paris'

For Monet, a Parisian by birth who had spent his childhood and adolescence at Le Havre, the French capital seemed rich in contrasts by comparison with the countryside and the sea. One of his earliest-known letters, written to Boudin from Paris on 3 June 1859, describes the first impact on the young artist of 'this stunning Paris'.

He seems to have been especially aware of the beauty of the Seine and its banks. 'I rose early, I had a delightful walk along the Quais and through the Tuileries, it was charming and I was entirely happy' (letter to Amand Gautier, 7 March 1864). On 20 May 1867 he wrote to Bazille: 'Renoir and I are still working on our views of Paris', referring to the pictures the two were doing from the Louvre.

Boudin, who lived in Paris but never used it as subject matter for painting, was fully aware of his friend's talent. 'We were talking of Monet', he wrote on 18 January 1869. 'At a dealer's on the Rue Lafayette, there is a view of Paris by him that would be worthy of the great masters, if the details were on a par with the ensemble. That boy has what it takes'

Run away from Paris ... or stay there?

In December 1868, Monet wrote to Bazille from Etretat describing his hesitations about Paris. 'I don't envy you being there ... don't you think that one does better when one is alone with nature? I'm sure of it. One's too preoccupied with what one hears in Paris ... and what I do here will at least have the merit of being unlike anyone else's work ... because it'll simply be the expression of what I personally felt myself.

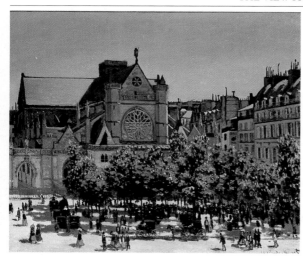

"Monsieur le Surintendant, I have the honour to request a special authorization to paint views of Paris from the windows of the Louvre, and notably from the outside colonnade, since I wish to try a view of Saint-Germain l'Auxerrois."
Letter to Count Emilien de Nieuwerkerke Superintendent of Fine Arts, 27 April 1867

The young Monet obstinately insisted on observing Saint-Germain-l'Auxerrois (1867, left) from a high elevation, painting the animation of Paris in the midst of a play of light and shade. In 1872, working with Renoir once again (below,

I really believe I won't come to Paris for long periods now, no more than a month each year.'

But there was one particular factor that led Monet to take a radical change of course. On 2 June 1869, shortly after moving to the hamlet of Saint-Michel near Bougival, we find him writing to Arsène Houssaye, an inspector at the Department of Fine Arts: 'You advised me to come and live in Paris, where it would obviously be easier for me to profit from what talent I possess. The rebuff by the Salon has completely made up my mind … we are now settled in, I am in excellent surroundings and keen to work.' On 25 April Boudin had written: 'Monet's two paintings have been *rejected* this year, but he has revenged himself by showing a study of Sainte-Adresse at one of our dealers, Latouche. The artistic fraternity is flocking to see it. There's been a crowd in front of Latouche's window … its unexpectedness and violence have gained Monet a *fanatical* following among the young.'

Monet often left Bougival to see his friends in Paris, and may even have posed with them for Bazille's *Studio on the Rue de la Condamine* (1870). He certainly appears in *The Batignolles Studio* (1870) by Henri Fantin-Latour. And it was in Paris that he married Camille Doncieux on 28 June 1870.

c. 1875), he painted *The Pont-Neuf* (photograph opposite).

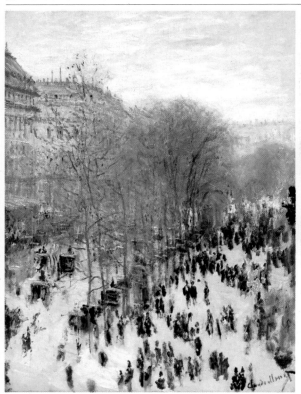

The studio on the Rue de l'Isly

On his return from England in the autumn of 1871 Monet stayed for a while at the Hôtel de Londres et de New York in the area near the Pont de l'Europe, then much favoured by artists and writers. He frequently worked in Amand Gautier's former studio, which he kept until 1874, giving as his address '8 Rue de l'Isly, near the Gare Saint-Lazare'. The station itself became a subject for him in 1877. For the time being, he and Renoir worked on their versions of the *Pont-Neuf* (1872).

Monet's place among the great painters of townscapes

Monet began by portraying the image of traditional Paris: the banks of the Seine, the Quais and the bridges

From a window at 35 Boulevard des Capucines (the studio of the photographer Nadar and site of the 1874 First Impressionist Exhibition) Monet painted the busy Paris of the boulevards. He conveyed the crowd of pedestrians with diminutive dark touches, which excited the irony of Louis Leroy: 'Here is an impression which baffles me ... please tell me the meaning of these innumerable black dribbles at the bottom of the canvas' (*Le Charivari*, 25 April 1874). A note of colour is supplied by the pink balloons.

Bazille (right), self-portrait in chalk.

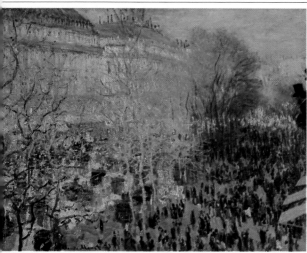

in the heart of the capital. Next, in 1873, he painted two pictures of the *Boulevard des Capucines* as seen from Nadar's studio, in which he expressed his fascination for Baron Haussmann's new rebuilding of Paris; it is 'this stunning Paris' with its happy, colourful crowds that now appears in his canvases. One of these scenes was shown in the First Impressionist Exhibition of 1874, where it provoked the scorn of Louis Leroy and other critics.

Monet's representation of these scenes of contemporary life answers to the criterion of 'modernity – that transitory, fugitive element', as advocated by the poet Charles Baudelaire in 1863. These 'urban landscapes' seen from above, these effects of mounting perspective, were also sought by Caillebotte and Pissarro. They betray the double influence on the Impressionists of the first photographs and particularly of Japanese prints: photographs with their instantaneous quality, and Japanese prints with their unusual viewpoints and flat planes of colour.

Japonerie and *japonisme*

Monet seems to have discovered Japanese prints in London, and then at Zaandam, well before they

became familiar to him in Paris. On 31 March 1875 the writer Edmond de Goncourt described in his *Journal* 'this great Japanese movement, which today is overflowing from painting into fashion. It began with a few originals, like my brother and I ... and was taken up after us by the group of Impressionist painters'. The 'japonisme' that enthralled Paris is brilliantly revealed in Monet's canvas entitled *La Japonaise* (which is sometimes called *Japonnerie*, as in the catalogue of the Second Impressionist Exhibition, 1876, or *Japonerie*, as at the Drouot auction of 14 April in the same year).

Monet's public gardens

If the gardens of Monet's various houses around Argenteuil can be seen as a kind of injection of town into country, his renderings of parks in Paris produce exactly the opposite effect. Ever since Sainte-Adresse he had been passionately interested in gardens, and now he dedicated several paintings to the two great 'promenades' of elegant and fashionable Paris society: the Tuileries and the Parc Monceau.

In the spring of 1876 Monet executed four views of the *Tuileries* (Manet and Renoir had done the same before him) as seen from Chocquet's apartment at 198 Rue de Rivoli. Three of these views were sold, to Dr de Bellio, Ernest May and Caillebotte.

At the Third Impressionist Exhibition of 1877, three pictures of *The Tuileries* were exhibited alongside a view of the *Parc Monceau*; in 1878 Monet completed a second version of the latter park, near which Ernest Hoschedé resided.

'I have just taken steps to obtain leave to paint in the Gare Saint-Lazare'

At about the time he told the publisher Georges Charpentier that he had rented a new studio in

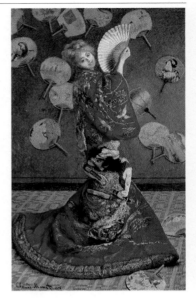

'*La Japonaise ...* a Parisienne in Japanese costume. My first wife was the model', said Monet in 1919 of this canvas, which was painted in 1875–6. More than just an imitation of the Japanese print style, the painting is a brilliant example of the 'japonisme' of the era, in its emphasis on decorative accessories (the actor's costume or kimono, fans and blonde wig).

Parc Monceau (1878): another study of light filtering through the trees.

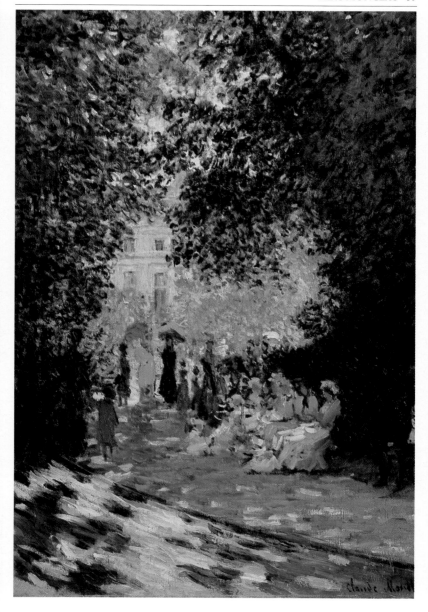

Claude Monet

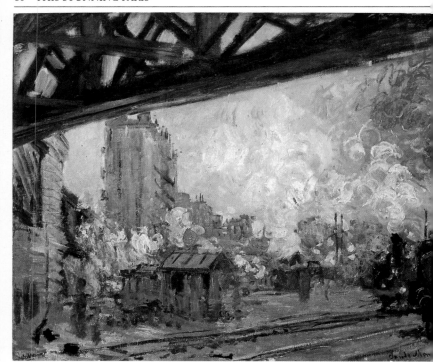

Caillebotte's name at 17 Rue Moncey near the Pont de l'Europe (17 January 1877), Monet embarked on a series of views of both the interior and exterior of the Gare Saint-Lazare. He showed the suburban trains which travelled to the places he had depicted outside Paris; he was less interested in the human presence, than in the spectacle of modern technology in action.

This choice of subject may seem odd for an open-air painter. Nevertheless, by taking an interest in a place so thoroughly characteristic of the epoch, Monet showed himself to be a true man of his time. The Gare Saint-Lazare – omnipresent in Zola's novel *La Bête Humaine* (1889–90), in which the writer gives a major role to a steam engine called 'Lison', and analysed by Proust in his *Remembrance of Things Past* – represented the new industrialization and the kind of glass and metal

"These great glassed-in workshops, like Saint-Lazare ... which spread above the gutted city like immense skies ... heaped up with drama, with an almost Parisian modernity ... beneath which only terrible and solemn acts can be accomplished, such as departing by rail."

Marcel Proust
Within a Budding Grove
1918

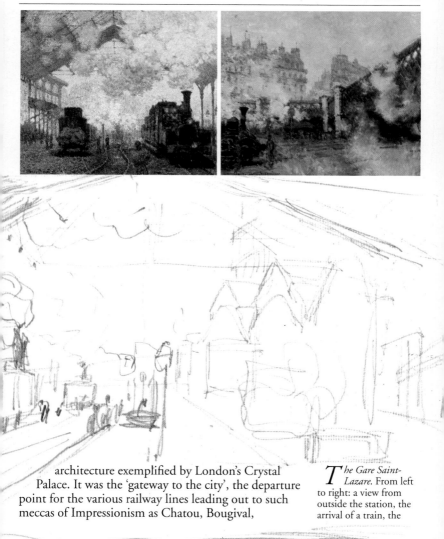

architecture exemplified by London's Crystal Palace. It was the 'gateway to the city', the departure point for the various railway lines leading out to such meccas of Impressionism as Chatou, Bougival, Louveciennes, Ville-d'Avray, Argenteuil, Vétheuil, Pontoise, Eragny, Giverny and Normandy.

The Gare Saint-Lazare. From left to right: a view from outside the station, the arrival of a train, the lines running under the Pont de l'Europe.

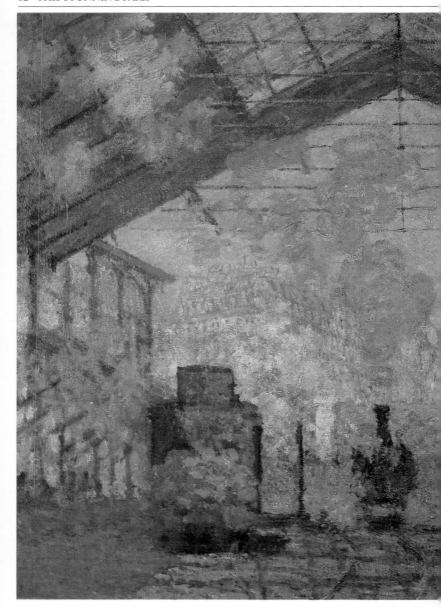

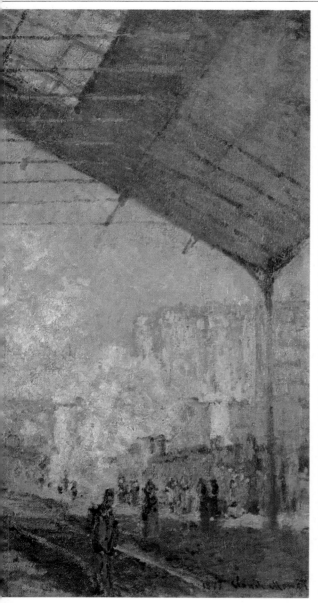

With *The Gare Saint-Lazare* (1877) Monet tackled two modern themes: the metal roof construction and the steam engine. The glass canopy creates a symmetrical composition centred on the moving train. In the background, the sunlight seems to fragment the facades of the buildings. In these stations, 'palaces of modern industry, where the religion of the century, that of the railways, is made manifest', in these 'cathedrals of the new humanity' (Théophile Gautier), Monet was enchanted by the light playing on clouds of steam escaping from the engines.

"Monsieur Claude Monet is the most marked personality in the group. This year he has exhibited some superb railway station scenes. In these one can hear the rumbling of the trains, and see the smoke rolling and flooding through the huge sheds. Here is the painting of today, in these beautiful, broad, modern canvases. Our artists must look to the poetry of railway stations, as their fathers sought that of forests and rivers."

Emile Zola
Le Sémaphore de Marseille, 19 April 1877

The station was not the only such subject to attract the Impressionists' attention; the curious iron girders of the Pont de l'Europe ('which is amazing on account of its bizarre shape and its sheer size', according to an 1867 guide) were an inspiration to Manet and Caillebotte as well as Monet.

At the Third Impressionist Exhibition of April 1877, in addition to his canvases of Paris public gardens, Monet presented eight views of the *Gare Saint-Lazare* (the eighth not included in the catalogue). The following year, at the final auction dispersing Ernest Hoschedé's art collection, Dr de Bellio purchased *Impression, Sunrise* (which was cited in the sales catalogue as *Setting Sun*).

'I am a countryman again'

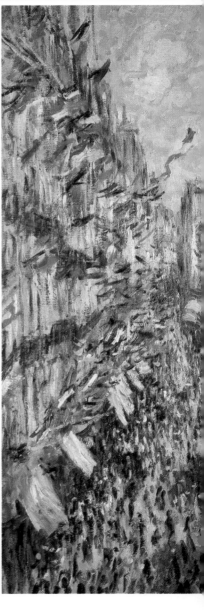

Obliged to leave Argenteuil in January 1878, Monet stayed in Paris with Camille and Jean for several months at 26 Rue d'Edimbourg, keeping the studio on the Rue Moncey. On 30 March he wrote to the collector Ernest May, 'My wife has just had another baby [17 March] and I find myself penniless and unable

EXPOSITION DES PEINTRES IMPRESSIONISTES

to pay for the medical care that both mother and child must have.' Appeals were also made to another patron, Eugène Murer, and to his friend Zola; finally the family's old friend Manet, who had acted as a witness at the registration of birth of the new baby Michel, once again came forward with the necessary help.

Monet now returned to the theme of gardens; ten paintings showing the banks of the Seine at the Ile de la Grande Jatte gave an intimation of the work that was still to come at Vétheuil.

Five years after painting *Boulevard des Capucines*, he once again captured on canvas the bustle of Paris on a national holiday, this time in the year of the Universal Exhibition (1878). The crowd effects in the flag-bedecked *Rue Montorgueil* and *Rue Saint-Denis* are Monet's brilliant farewell to Paris, which now disappears from his work for ever. 'I am a countryman again, and I shall not come to Paris save at intervals, to sell my pictures', he wrote to Duret from Vétheuil on 8 February 1879.

'I loved flags. The first national holiday of 30 June, I went walking in Rue Montorgueil: the street was decked with pennants, there were lots of people; I saw a balcony and went up to it' (letter to René Gimpel, October 1920). *Rue Montorgueil* is another view painted from above, with a rising perspective borrowed from Japanese prints and photography. The play of diagonals makes for a rigorous composition.

At left, Manet photographed by Nadar, 1865. Above, caricature in *Le Charivari*, April 1877: a pregnant woman turned away from the Impressionist exhibition for fear of a miscarriage.

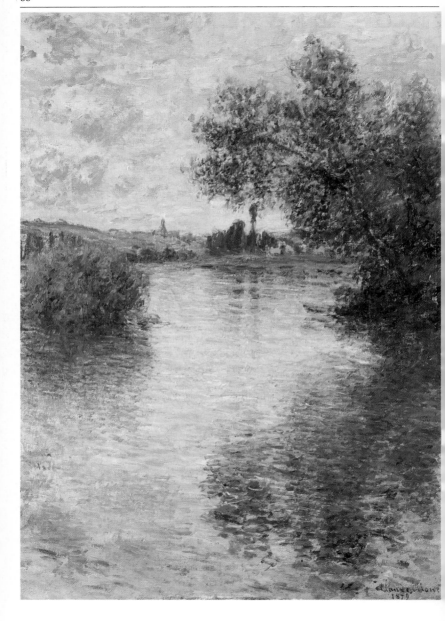

'You may have heard that I have pitched my tent on the banks of the Seine at Vétheuil, in a ravishing place' (Monet to Murer, 1 September 1878). The river became the subject of a series of winter landscapes (*Ice Floes*); these canvases are filled with Monet's sadness at the death of Camille, an event that marked the end of his youth and came at a time when the Impressionist movement was disintegrating.

CHAPTER 4

"ON THE BANKS OF THE SEINE AT VETHEUIL"

The Seine at Vétheuil (1879): here Monet has opted for a vertical format, unusual for the Vétheuil period. The horizon divides the composition between sky and water in a harmony of blues and greens. Monet *c.* 1879 (right).

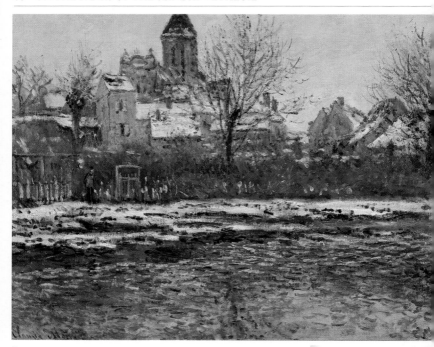

The village of Vétheuil, on the right bank of the Seine, occupies a favourable situation; from its raised site it dominates a loop of the river that is sprinkled with wooded islands. This distinctive landscape was bound to attract Monet. First of all he set about painting the houses grouped around the church.

His tireless attempts to master the constant variations in light playing over the same scene indicate Monet's fondness for his adopted village. Scarcely changing the position of his easel at all, he persisted at Vétheuil in his study of light and his research into new compositional formats. The resulting canvases were quickly sold to Caillebotte, Duret and Dr de Bellio.

'I cannot hope to earn enough money from my paintings to pay for our life here at Vétheuil'

At Vétheuil, Monet and his family occupied a house on the road out to Mantes, which they shared with Alice

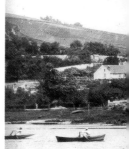

During his first winter at Vétheuil, Monet several times painted the village under snow: *The Church at Vétheuil, Snow* (1878–9, top).

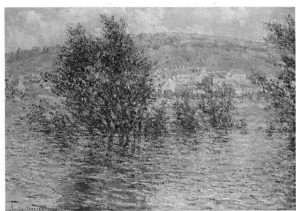

To obtain a panoramic view of Vétheuil, Monet used his studio-boat on the Seine, set up his easel on one of the islands, or else crossed the river and worked from the far bank (left). In these landscapes, which at first sight seem similar, a different effect appears at each attempt – 'effect of snow' (opposite) and *Effect of Sunshine after Rain* (left). Here the artist applies a technique he had perfected at Argenteuil: the fragmented brushwork simulates the moving water, while the architectural outlines resist the dissolving effect of light.

and Ernest Hoschedé and the two couples' six children, partly in an attempt to save money. The house had an orchard leading down to the river, where Monet moored his studio-boat. Later, in December 1878, the families moved to more comfortable quarters, on the road to La Roche-Guyon. In Paris, meanwhile, Monet forsook his studio on the Rue Moncey for another at 20 Rue de Vintimille.

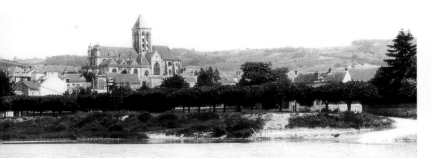

The house at Vétheuil enabled him to concentrate as never before on his vision of nature, without the distractions of city life, but it also contributed to Monet's growing isolation from his Impressionist friends. Unwillingly he agreed to submit twenty-nine works to the Fourth Exhibition of paintings by the group at 28 Avenue de l'Opéra in Paris; but 'it was much against my

At Vétheuil (photograph above), Monet's main preoccupations were the interplay of earth and sky, and the landscape mirrored by the river.

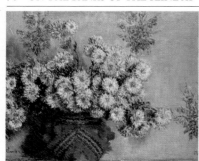

will – and only to avoid the charge of treachery' (letter to Murer, 25 March 1879), and also because he desperately needed the money.

Unable to pay either his rent or his debt to Manet for the expenses of the move, Monet considered uprooting his family yet again (letter to Ernest Hoschedé, 14 May 1879): 'Only I know how deep are my anxieties and the trouble I have in finishing my canvases, which don't satisfy me, and indeed please very few other people. I am totally discouraged ... I must accept the hard fact that I cannot hope to earn enough money from my paintings to pay for our life here at Vétheuil We can't be very good company for you and Madame Hoschedé, myself more and more embittered, and my wife nearly always sick Our departure would be a relief for everyone in the house, even though I believed I could create dreams of work and happiness here'

'My poor wife died this morning'

In the letters he wrote to Dr de Bellio, Monet revealed his concern about the health of Camille, who had been 'extremely frail' ever since the birth of Michel. On

Monet rarely painted flowers indoors; autumn prompted him to paint *Chrysanthemums* (1878, above left).

5 September 1879 he wrote 'My poor wife died this morning I am filled with dismay to find myself alone with my poor children. I want to request another service of you: to redeem the medallion we pawned at the Mont de Piété with the enclosed money. It is the only souvenir that Camille had been able to preserve, and I would like to put it round her neck before she leaves us.' This final loving gesture shows the artist's undimmed affection for the companion of his early years, even though recent events had shown that this phase of his life was now finished forever.

On 26 September a distraught Monet wrote to Pissarro: 'You, more than anyone, will understand my grief. I am overwhelmed; I have no idea which way to turn, nor how I am going to be able to organize my life with my two children. I am much to be pitied.'

That autumn, probably on account of the bad weather, he abandoned outside work and concentrated on compositions of fruit and flowers; the shooting season inspired some fine still lifes of dead game. Monet's decision to paint still lifes following Camille's death may also have resulted from pressing financial worries, for he and his family were now threatened with eviction, and still lifes sold for higher prices than his landscapes.

*C*amille Monet in 1871 (above).

*C*amille Monet on her *Deathbed* (1879, left). This canvas, which is handled like a 'snow effect', reveals Monet's concern with colour analysis.

"At the deathbed of a woman who had been very dear to me, I surprised myself in the instinctive act of tracing the successions and gradations of colour that death had just imposed upon her still face. It was a natural desire to preserve a last image of one about to leave us forever But before the idea of capturing those features ... even occurred to me, at the deepest level of my being I reacted instinctively to the shocks of their colour."
Monet quoted by Georges Clemenceau 1928

A hard winter

With the exceptionally hard winter of 1879–80, the Seine suddenly became Monet's only subject matter.

The river froze over almost completely, and a memorable thaw followed, with huge ice floes driven down by the current. This event fascinated the artist, who felt a growing interest in atmospheric phenomena; it also gave him a chance to paint several spectacular compositions, with effects that differed according to the angle of vision and the time of day. Monet would soon not need to move his easel at all, or only very slightly, to allow the

"We have had a terrific breakup of ice here, and naturally I have tried to do what I can with it."
Letter to Dr de Bellio
8 January 1880

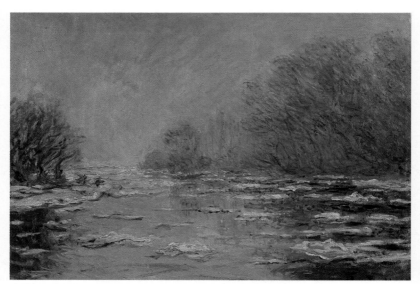

shifts in form and colour caused by changes in the light to exclude all other subject matter from his work.

His Vétheuil pictures also seem to possess a peculiarly emotional dimension. These cold-toned landscapes are empty of any living thing; sky and water often share the same wintry pallor, silence and desolation. They reflect the material and moral anxieties that were oppressing Monet. As if by a mysterious 'association', such as one might find in the poetry of Charles Baudelaire, nature had united with Monet's private melancholy.

It has been suggested that the *Ice Floes* should be read as symbolizing the painter's lot at this time: the breaking of the ice illustrates both the breakup of the

The entire foreground of *Ice Floes at Vétheuil* (1880) is composed of water; the vertical shapes of the trees mirrored in the water provide a counterbalance. Monet distinguishes in his brushwork between the moving water and the hard blocks of ice; the juddering ice itself is rendered by disjointed touches and thickened paint surfaces.

Impressionist group, and the turning point in Monet's private life – for the death of Camille, the model for much of his early work, had defined the end of an era.

A double challenge: The Salon and a first solo exhibition

Having remained aloof from the Salon since 1870 – when the jury had yet again rejected his submissions

Ice Floes on the Seine (1880): this work belonged to Charles Ephrussi, a collector who is said to have been the model for Marcel Proust's character Swann.

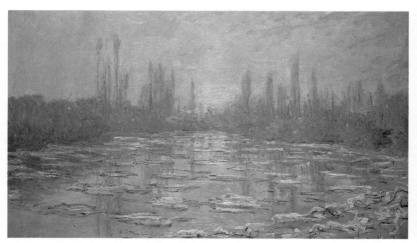

– Monet decided to take up the official gauntlet one more time in 1880. Renoir's success the year before, with his *Portrait of Mme Georges Charpentier and her Children*, may have had something to do with this change of heart. Knowing that this act would be condemned by the Impressionists as treason, especially since he, Monet, had helped found the movement in 1874, the artist took care to write to Duret explaining that his only motive was to sell paintings.

Only one of his two submissions, *Lavacourt*, was accepted, but was exhibited poorly. Zola did not hesitate to criticize Monet's too hastily executed canvases, though he acknowledged his talent and forecast his future success: 'Within ten years, he will be accepted, displayed and rewarded; he will sell his pictures for huge prices and will stand at the head of the present movement'

"Everything shimmers ... this thaw is all a mirage; you see no difference between the ice and the sunshine, and all these floes of ice break up the hues of the sky and sweep them away, and the trees shine so that one cannot tell if their russet colour comes from autumn, or from their species, and one no longer knows where one is, nor if this is the bed of a river or a woodland clearing."
Marcel Proust

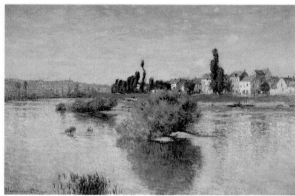

('Naturalism at the Salon', III, *Le Voltaire*, 21 June 1880).

Monet's return to the Salon coincided with his abandonment of the fifth exhibition by the Impressionists – who had called themselves 'independent artists' since the previous year. This confirmed the breakup of the group, which had anyway begun with the defections of Renoir, Sisley and Cézanne. In June the first private exhibition entirely devoted to Monet was held at the gallery of the *Vie Moderne*, a magazine founded in 1879 by the publisher Georges Charpentier. The catalogue, with a preface by Duret, included eighteen works. The several sales that ensued gave Monet a chance to pay off his creditors and brought him fresh hope and courage. 'I am working a lot, and am on the right track', he wrote to Duret on 5 July 1880.

In August he took part in the '1880 Exhibition' of the Le Havre Friends of the Arts Society. His paintings, including the Salon entry, were ill-received in his home town. On the other hand, the seascapes that he painted on the Normandy coast during the next few years enjoyed more success in Paris.

"For the Salon, I had to do something more restrained and bourgeois."
Letter to Duret
8 March 1880

Monet's landscape of *Lavacourt* is more a careful description than a personal interpretation of the subject. The fragmented brushwork in the handling of the water is restrained beneath a smooth paint surface. Here he sacrifices 'immediacy' to give a more conventional aura to his canvas, which was accepted by the Salon and noticed by Zola (below).

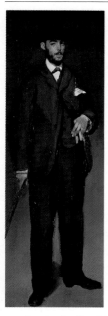

'I must soon leave Vétheuil, and I am looking for a pretty place by the Seine. I have been thinking about Poissy' (letter to Zola, 24 May 1881)

After the death of Camille, Monet's domestic situation and that of the Hoschedés became confused; business seems to have kept Ernest in Paris, while Alice justified her decision to stay with Monet by the

In his painting of Théodore Duret (1868) Manet stresses the elegance of a man he called 'the last of the dandies'. The work was inspired by the Spanish painter Francisco de Goya, and indeed it was in Madrid that Manet first met Duret, an art critic and a loyal supporter of Monet.

LE PEINTRE

CLAUDE MONET

NOTICE SUR SON ŒUVRE

Par Théodore DURET

SUIVIE DU CATALOGUE DE SES TABLEAUX

Exposés dans la galerie du Journal Illustré

LA VIE MODERNE

7, boulevard des Italiens, 7

LE 7 JUIN 1880 ET JOURS SUIVANTS

need to look after his two sons.

The Vétheuil period constitutes a major transitional interlude between Argenteuil and Giverny. Monet's life and career now began to move in new directions that were decisive for the future. First, he had reached a mature age and had not only assimilated his previous artistic experiences but also acquired his independence, by detaching himself from the old Impressionist group. Second, with the death of Camille and the growing importance to him of the woman who was later to become his second wife, his private life took a different course. Finally, the sustained support of Durand-Ruel seemed to augur better days to come. All these hopeful signs are marvellously captured in the

The names of Monet and Duret on the catalogue for Monet's 1880 exhibition. On 8 July Monet wrote to Duret: 'I am sending you a souvenir of my exhibition, with which you so courageously assisted me.'

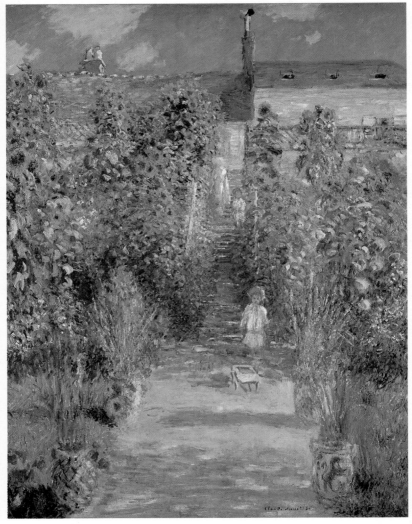

The Artist's Garden at Vétheuil (1881): fragmented brushwork makes the sunflowers shimmer.

canvas that immortalizes the *Artist's Garden at Vétheuil*, a few months before his departure. In December 1881 (mostly thanks to Durand-Ruel, who paid for the move) Monet abandoned the right bank of the Seine to set up house with Alice Hoschedé and the children at Poissy, in the Villa Saint-Louis, another house near the river.

Durand-Ruel: A many-sided, effective and loyal supporter

At the beginning of the 1880s the name of Georges Petit disappears from the roster of Monet's buyers and is replaced by that of Durand-Ruel, who was to supply the artist with unflagging moral and financial aid thereafter. As the years went by, Durand-Ruel gained more and more influence, eventually supplanting the old group of patrons (the singer Jean-Baptiste Faure, Duret, the director of the *Gazette des Beaux-Arts* Charles Ephrussi, Dr de Bellio and Murer), to whom Monet now refused to sell his work for low prices. Durand-Ruel's purchases, which came steadily after February 1881, allowed Monet

Painted on a hillside at Vétheuil, this 1880 picture records an 'effect of spring' in the Seine valley. The canvas, which is bare in some places, is thinly covered with light, bright colours which suggest the limpidity of the air and the evanescent clouds. The tree, which has just come into bud, is reminiscent of the flowering almonds of Japanese prints and is sufficient to convey the rebirth of nature. After the memorable 1880 winter, Monet welcomes the return of warm weather.

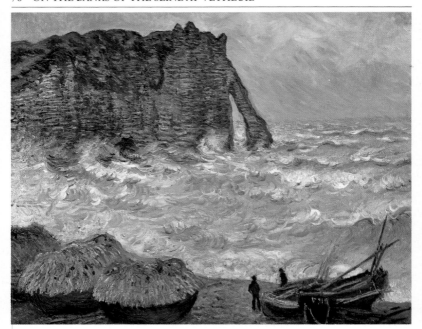

to forsake the Salon entirely and to hold aloof yet again from the Impressionists, or Indépendants, as they now called themselves, who mounted their 'Sixth Exhibition of Paintings' in the same year.

In 1882, however, the collapse of the Banque de l'Union Générale hit Durand-Ruel hard; Monet's reaction was to change his mind and take part in the 'Seventh Exhibition of Independent Artists' to the tune of thirty-five canvases. This exhibition was organized in March at the Panorama de Reichshoffen (251 Rue Saint-Honoré, Paris). Although some journalists, notably Joris-Karl Huysmans in 1880, continued to find fault with the Impressionist vision and with Monet's highly personal use of colours, the seascapes he showed were greatly admired.

Following a burst of intense creativity at Pourville on the Normandy coast, where he tackled several new

Each time he sold a painting, Monet

Rue de la Paix, N° 1.
près la place Vendôme
DURAND-RUEL
Vente et location
de Tableaux et Dessins.

made a careful note both of its price and of its buyer; thus under 13 January 1884 (right) he noted the canvases acquired by Durand-Ruel (photographed here *c.* 1910).

subjects, Monet went through a period of uncertainty during the winter and following summer: 'The future seems very black. Doubt has overtaken me, I think I'm lost and can do nothing more' (letter to Durand-Ruel, 18 September 1882). With his usual generosity, the dealer, who had become Monet's friend, responded with money and abundant advice; he exhibited canvases by Monet in London and Berlin, and in October bought twenty of the pictures completed in Normandy.

It was also in 1882 that Monet began the decoration of the large drawing room in Durand-Ruel's apartment at 35 Rue de Rome, on which he was to work until 1885. In March 1883 the dealer mounted an exhibition of fifty-six of Monet's paintings in his new gallery near

A 'terrible storm', in Monet's own words, gave him the chance to paint his spectacular *Rough Sea at Etretat* (1883), of waves battering the Aval cliffs. In the foreground, two silhouetted fishermen watch the spectacle.

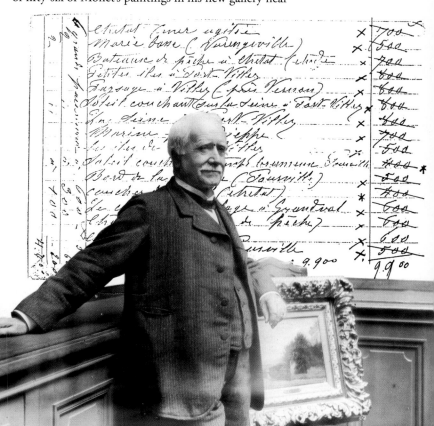

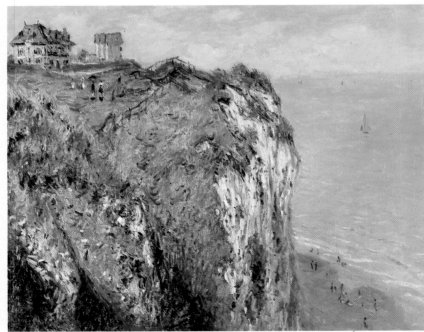

the Madeleine in Paris. The indifference of the press and public on this occasion was a heavy blow to Monet, who blamed Durand-Ruel for preparing the exhibition badly.

'I am going to travel around until I find a house and a landscape that suit me' (letter to Durand-Ruel, 5 April 1883)

On several occasions Monet expressed his aversion 'to this wretched Poissy', which inspired him not at all: 'The countryside won't do for me', he wrote to Durand-Ruel on 27 May 1882. In effect, his short interlude at Poissy was a failure, his important work that year being mostly done on the Normandy coast. His letters to Alice Hoschedé reveal the growing intimacy between the two at this time:'Remember that I love you and cannot live without you' (Etretat, 12 February 1883).

No doubt the dissatisfaction Monet felt with Poissy helped him to realize his vital need to find a suitable

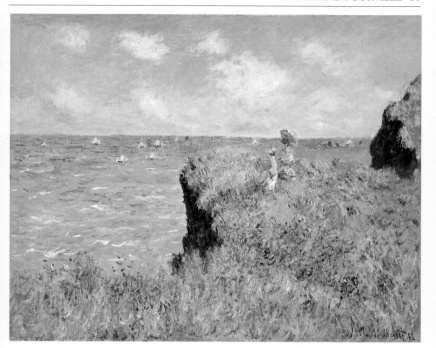

place to work. At the age of forty-two, he now required real stability. Thus began his search through the country to fulfil his longstanding aim, which he reiterated to Durand-Ruel: 'Once I get properly installed', he wrote on 5 April 1883, 'I shall come to Paris only once a month on dates decided in advance.' The year before, he had given up his Paris studio on the Rue de Vintimille.

The move from Poissy was again paid for by Durand-Ruel, and Monet acknowledged that 'all this makes a great deal more money that I owe you, but once I am set up I hope to paint masterpieces, because the country here pleases me very much'. He had discovered Giverny.

In 1882, with *The Cliffs near Dieppe* (opposite), Monet conveys the often dramatic rocky seashore precipices of the Caux region. By contrast, the light-filled canvas above evokes the happy atmosphere of a summer *Cliff-walk at Pourville*. The figures (perhaps Alice Hoschedé and one of her daughters) stand out against the sea.

A letter from Monet to Durand-Ruel (left), written from Poissy on 20 December 1881.

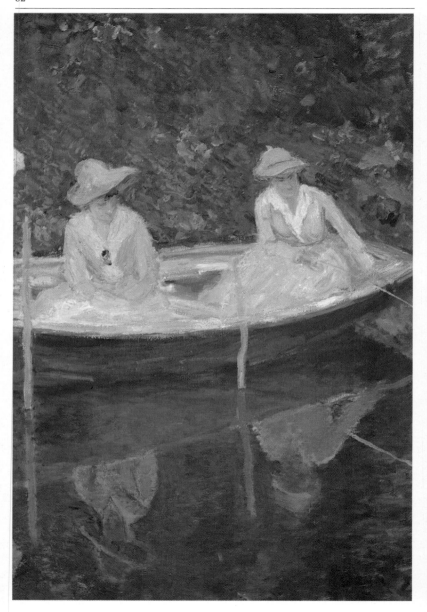

'I am in ecstasy. Giverny is splendid country for me', wrote Monet to Duret in 1883. Through all his painting expeditions of the 1880s, the artist never tired of expressing in his letters his growing attachment for this village on the junction of the Epte and the Seine. Seven years later, 'certain of never finding a comparable house nor such beautiful countryside anywhere else', he bought the property at Giverny.

CHAPTER 5

"GIVERNY IS SPLENDID COUNTRY FOR ME"

Monet communicated his passion for boating to his family. In *Boat at Giverny* (*c.* 1887, detail) he painted the Hoschedé girls (Suzanne, left, and Blanche) fishing on the River Epte near the house. Monet *c.* 1887 (right).

Monet's discovery of the Mediterranean coast

No sooner was he established at Giverny in 1883, with Alice Hoschedé and the children, than Monet learned with sadness that his friend Manet had died on 30 April.

In December, Monet went for the first time to the Mediterranean coast, in company with Renoir; after visiting Cézanne at Aix-en-Provence, the two artists pressed on into Italy, travelling as far as Genoa. Then, in January of the following year, Monet returned to spend three months on the Riviera, staying just over the Italian border 'at Bordighera, one of the most beautiful places we have seen on our trip. I hope to bring back a whole series of new things. But I ask you to tell *no-one* of this voyage ... because I insist on *doing it alone* ... I have always worked best in solitude and according to my own impressions' (letter to Durand-Ruel, 12 January 1884).

Bordighera, then largely a winter resort, is known for the softness of its climate and the tropical luxuriance of its vegetation. Monet felt that he had found an 'earthly paradise': 'One can wander indefinitely under the orange trees, lemon trees and palms, and also beneath the admirable olives ... I should like to paint orange and lemon trees standing against the blue sea ... as to the blue of the sea and sky, it is impossible' (letter to Alice Hoschedé, 26 January 1884).

To convey the light and atmosphere of the region, Monet used unaccustomed tones, of which he took care to forewarn Durand-Ruel in a letter summing up his stay in Liguria: 'It may draw howls from the enemies of blue and pink, for it has exactly that brightness and fairy light, and I am determined to catch it. Everything is pigeon-breast and burning

Villas at Bordighera (1884, opposite, details below and far right) shows in the foreground the villa built in 1880 for Baron Bischoffsheim by architect Charles Garnier, seen from the Moreno gardens. To paint the Ligurian landscape 'one would need a palette of diamonds and gemstones' (letter to Duret, 2 February 1884).

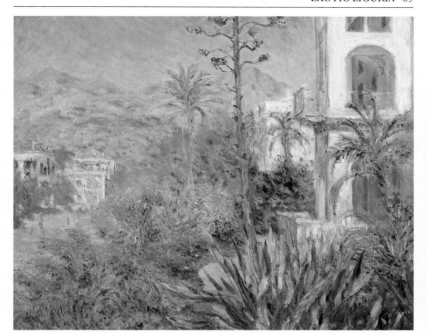

punch, it is wonderful and every day the country is lovelier, and I am enchanted' (11 March 1884).

'Rounded like a new moon, the little town of Etretat, with its white cliffs, its white shingle and its blue sea, lay in the sunshine' (Maupassant, *Le Modèle*, 1883)

"Here I will concentrate on the palm trees and the more exotic features."
Letter to Durand-Ruel 23 January 1884

Between 1883 and 1886, Monet regularly went back to Etretat; the picturesqueness of its site seems to have attracted him as much as the sky and sea. A fellow visitor to the Caux region was the writer Guy de Maupassant, who made it the setting for a great many of his stories. Maupassant shared Monet's admiration, and between the exactly contemporary works of the two men, who met several times at Etretat, there are strong links.

The cliffs at Etretat and the Porte d'Aval (pencil drawing from a sketchbook, *c.* 1883, left).

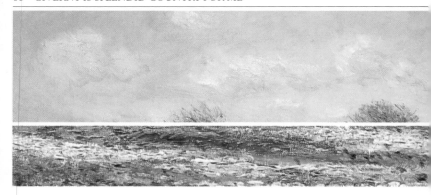

Following in the footsteps of Courbet and Boudin, Monet painted the striking rock formations of the Porte d'Amont, the Manneporte and the Porte d'Aval, sometimes with the 'Aiguille', a needle-shaped rock. 'You can have no idea of the beauty of the sea ... as to the cliffs here, they are like nowhere else' (letter to Alice Hoschedé, 3 February 1883).

Spring 1886: A few days in Holland

Monet was fascinated by the fields of tulips between Leiden and Haarlem. He brought home five paintings of them, which he finished in his Giverny studio.

Here he treated the sky with a certain lightness, but the size of the space it occupies suggests the broadness of the Dutch skyline while at the same time giving precedence to the flowers. Two versions of this subject appeared on 15 June 1886 in the 'Fifth International Exhibition of Paintings and Sculptures' at the Georges Petit Gallery, where they provoked this comment from Huysmans: 'There are fields of tulips in Holland by Claude Monet, which are overwhelming! A true feast for the eyes' (letter to Odilon

Redon, 28 June 1886). 'Everything in the show was sold for high prices to good people', Monet wrote to Berthe Morisot.

The hunt for buyers

Though Durand-Ruel's financial problems worried Monet enough to make him consider dealing directly with buyers, he admitted that 'because I know how far I have come, thanks to you, ... I am aghast at the thought of going out after

M onet's enthusiasm for Holland comes through in the Duke of Treviso's record of his remarks (*Le Pèlerinage de Giverny*, 1927): 'You don't like tulip fields? You find them too regular? I love them, and I love it when they gather the old flowers to pile them up, and suddenly on the little canals one sees rafts of colours floating, like yellow stains in the blue mirror of the sky' – an effect that comes across here (*Tulip Fields at Sassenheim near Haarlem*, opposite below, and details above). The painting is very heavily worked, and the undulation of the tulips in the wind is rendered by rapid strokes of the brush.

buyers all over again' (letter to Durand-Ruel, 18 May 1884).

In his anxiety to dispose of his work, Monet took part in several of the International Exhibitions organized annually by Georges Petit. He tried to convince Durand-Ruel that he too would benefit from the success of this rival; in effect, he began to share his work between the two dealers. For example, at the 1886 exhibition by a group of painters called 'Les Vingt' in Brussels, Monet's contributions were lent equally by Petit and Durand-Ruel.

On the other hand, Monet was reticent about Durand-Ruel's American forays on his behalf. 'I would like to share your hopes for America', he wrote on 23 January 1886, 'but I would prefer, above all, to have my paintings known and sold here.' Nonetheless, forty

T he pages of Monet's address book (centre) show the names of friends and collectors such as Faure, Caillebotte and Dr de Bellio, and dealers like Théo van Gogh and Georges Petit. It was in Petit's gallery that this version of *Tulip Fields* was exhibited in June 1886.

of his canvases appeared at the exhibition of 'Oil Paintings and Pastels by the Paris Impressionists', which was held in New York in 1886. Largely thanks to the support of the American-born painters Mary Cassatt and John Singer Sargent, this show was a great critical success in America.

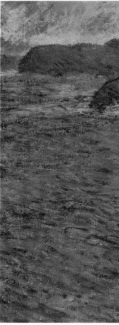

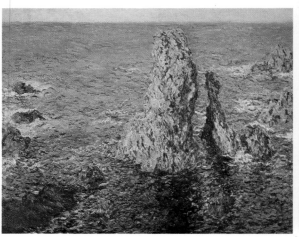

'The sea is completely beautiful, and as for the rocks, they are a tangle of extraordinary coves, spikes and needles' (letter to Alice Hoschedé, 18 September 1886)

'Yearning to go to Brittany', as he explained in a letter to Berthe Morisot, Monet travelled to Belle-Ile in the Gulf of Morbihan during the autumn of 1886. Here he stayed at a fisherman's house in the village of Kervilahouen, near the western shore of the island, a wild place facing the open sea. This part of

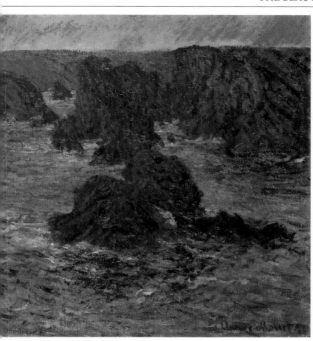

"I am in a superbly wild country, amid a chaos of jagged rocks and a sea filled with unbelievable colours; I am fascinated, though having a deal of trouble, because I was used to painting the Channel and obviously had my own routine, and this ocean is something very different."
Letter to Caillebotte
11 October 1886

Monet's first contact with the Atlantic deeply disconcerted him. He painted several scenes of Belle-Ile, including the spectacular *'Pyramides' of Port-Coton* (opposite above, and photograph below) and the Bay of Port-Domois with the Roche Guibel. This pierced rock figures on the canvas he gave to Rodin, *Belle-Ile* (left). The line of the horizon is often placed very high; Monet was intrigued by the incessant struggle between land and sea on this rugged coast, and he made full use of the clash between the rocky masses and the foam-flecked waves.

Belle-Ile inspired about forty paintings, divided into several groups according to the place and the weather.

Here again, it is premature to talk about a 'series', because with each picture Monet changed his angle of attack. Nevertheless, he was unconsciously turning over the idea in his mind: 'I know that to paint the sea truly, you have to see it every day at all hours and at the same spot, so you get to understand the life of it at that spot; so I do the same subject sometimes four or even six times over' (letter to Alice Hoschedé, 30 October). This period in Brittany gave Monet the chance to employ, though instinctively and unsystematically, a way of approaching his subject matter that he would later develop into a more organized procedure.

At Belle-Ile, Monet met Gustave Geffroy, art critic for the politician Georges Clemenceau's radical newspaper *La Justice.* Geffroy, who became one of his ardent defenders as well as a close friend, recalled Monet

"Monet worked in the wind and rain. His easel was anchored down with cords and stones."
Gustave Geffroy
Claude Monet, 1924

working in terrible storms, with his easel tied to a cliff. Monet was also visited by the writer Octave Mirbeau, who in return invited him to Noirmoutier.

'After wild Belle-Ile, this will be very soft: there's nothing here but blue, pink and gold' (letter to Duret, 10 March 1888)

Monet spent the first months of 1888 on the Mediterranean coast. On the recommendation of Maupassant, whom he met at Cannes, Monet stayed at the Château de la Pinède in Antibes, an artists' hotel where the landscape painter Henri-Joseph Harpignies was also staying. Here Monet executed about thirty canvases: 'I fence and tussle with the sun ... one should paint here with gold and gemstones' (letter to Rodin, 1 February 1888) – an image already suggested by Bordighera. Some of his motifs form groups of two or three canvases, but no group emerges as a true 'series'.

To convey the light of the Mediterranean, Monet used a palette of delicate tones akin to pastels. In this freely painted canvas, *Antibes seen from the Cap* (left, details above), the brushwork exactly imitates the effect of the Mistral passing over the vegetation.

In June Monet sold ten of his canvases to Théo van Gogh, Vincent's brother, who was working for the dealers Boussod and Valadon (formerly Goupil's). Théo exhibited the paintings, which journalist Félix Fénéon described in the *Revue indépendante* as 'Ten Antibes

Seascapes', in the showroom adjoining the gallery (19 Boulevard Montmartre). Though this exhibition pleased neither Fénéon nor Pissarro (who was then preoccupied with Neo-Impressionist theories), it was a great success with Maupassant, Mallarmé and Geffroy. Morisot described its impact in a letter to Monet: 'You have really won over the public, mulish as it is. The people one sees at Goupil's are full of admiration.'

Fortified by the acquisition of a new buyer, Monet refused to take part in the group exhibition that opened

In *Antibes seen from La Salis* (below and in photograph) Monet paints a panorama of the old town, 'a small fortified place gilded by the sun, which stands out against beautiful blue and pink mountains' (20 January 1888).

on 25 May in the Paris gallery of Durand-Ruel, of whose efforts to promote his work in the United States he still disapproved.

The valley of the Creuse

'Here I am again grappling with the difficulties of a new landscape. It's superb here, with a terrible wildness that reminds me of Belle-Ile. I thought I would do astonishing things, but the further I go, the more trouble I have in conveying it as I would like' (letter to Morisot, 8 April 1889).

Among the twenty-odd paintings inspired by the Creuse, groups of two or three stand out as before; but now for the first time a much more important ensemble appears, which includes no fewer than nine works. After the *Ice Floes* of Vétheuil, the *Cliffs* of Varengeville, the Dutch *Tulip Fields*, and the seascapes of Belle-Ile and Antibes, which constituted a progressive, unconscious, serial approach to given subjects, it seems that these nine views of the Creuse gorge finally brought the series idea to fruition. The number of versions executed by Monet of a subject viewed from a nearly identical vantage point has suddenly increased; the single most important feature has become the variation of the light. These nine landscapes really deserve to be called a 'series', a word the artist himself used to describe them: 'With this awful gloomy weather ... I am terrified when I look at my paintings, they are so dark. Moreover, some of them even lack sky. It's going to be a lugubrious series' (letter to Alice Hoschedé, 4 April 1889).

In a letter dated 24 April, Monet told Geffroy about the trouble he was having painting this landscape, mostly due to the season. 'I am continually forced to make changes, I follow nature but cannot catch her, and

"Monet lingered to contemplate the frothing currents which met beyond the rocks on a pebbled bed ... the stony hills formed a dark arena around this watery tumult. It was a savage, infinitely sad spectacle."
Gustave Geffroy
Claude Monet, 1924

In Monet's nine pictures of the junction of the Grande and the Petite Creuse, earth and water share the canvas equally. These works mainly differ in their light effects, which vary with the time of day. The three shown here are of evening: *Creuse Valley at Dusk* (above), *Evening Effect* (above right) and *Sunset* (below right). Their daring choice of colours captures the effect of night beginning to fall on the landscape.

then there is this river, the level of which drops and rises, which is one day green, the next yellow, the next nearly dry, and which tomorrow may just as easily be a raging torrent.' Again from Fresselines, he wrote to Georges Petit on 21 April: 'The main thing for me is to be able to be ready in time.' During this period, Monet was thinking constantly about the coming

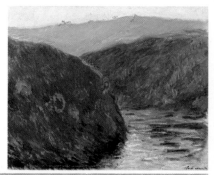

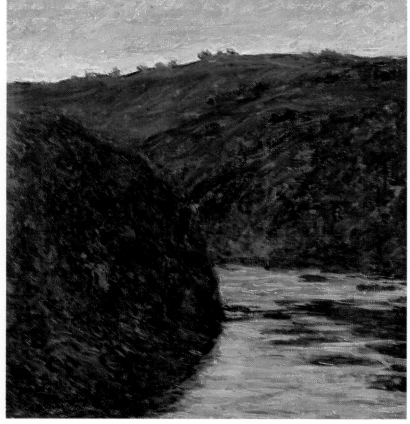

exhibition at the Rue de Sèze in Paris, when his paintings would be shown with sculptures by Auguste Rodin.

'They are the men who in this century have most gloriously and definitively personified the twin arts of painting and sculpture' (Mirbeau, *L'Echo de Paris*, 25 June 1889)

As a great admirer of Rodin, Monet was keen to share an exhibition with this officially recognized artist. '*Nothing but you and I*', he wrote to Rodin on 28 February 1889. 'We could do something fine together.' The catalogue included 145 entries for Monet, 36 for Rodin; the preface on Monet was signed by Mirbeau, and Rodin was introduced by Geffroy. The sculptor was especially preoccupied by his group *The Burghers of Calais,* which was being shown for the first time; as for Monet, he viewed the affair as a retrospective of twenty-five years of work, with pictures spanning his career between 1864 and 1889. 'A résumé of the painterly existence of Claude Monet', wrote Geffroy in *La Justice*, 21 June 1889. In spite of a few criticisms, the press largely approved.

After the opening of the exhibition on 21 June Monet wrote to Georges Petit: 'I saw that my panel at the back is completely lost now that the Rodin group has been set up. The mischief is done; it is very upsetting to me. If Rodin had understood that since we were exhibiting together we should have

GALERIE GEORGES PETIT
8, rue de Sèze, 8

CLAUDE MONET

A. RODIN

PARIS
1889

Monet had long wished to see his name united with Rodin's; this wish was finally realized on the cover of the catalogue for their 1889 joint exhibition (above).

Rodin, *c.* 1887, and his *Burghers of Calais.*

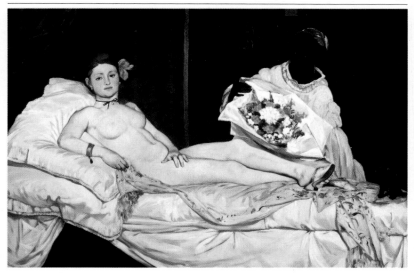

agreed on the placement of our work ... if he had discussed it with me and given a little consideration to my work, it would have been quite easy to work out a fair arrangement without doing each other harm. I only want one thing now and that is to get back to Giverny and have some peace.' An open quarrel between these two great artistic temperaments was only just avoided. Curiously, the two men's birthdays were only forty-eight hours apart (Rodin was born on 12 November 1840, Monet on the 14th).

"Monsieur le Ministre, in the name of a group of subscribers, I have the honour to present to the State *Olympia* by Edouard Manet."
Letter to Armand Fallières 7 February 1890

The subscription for Manet's *Olympia*

Three works by Monet had been shown at the 'Centennial of French Art', which opened in May to mark the 1889 Universal Exhibition.

Also displayed at this time was Manet's *Olympia*, which had caused a scandal at the 1865 Salon. Monet decided to organize a subscription among the friends and admirers of Manet, to buy his *Olympia* and donate it to the Louvre. 'It's a fine gesture of homage to his memory, and at the same time a discreet way of helping out his widow, to whom this painting belongs', he wrote to Rodin on 25 October 1889. Morisot, Manet's sister-in-law, told Monet that

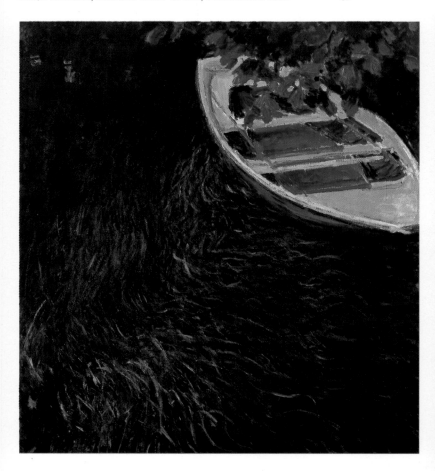

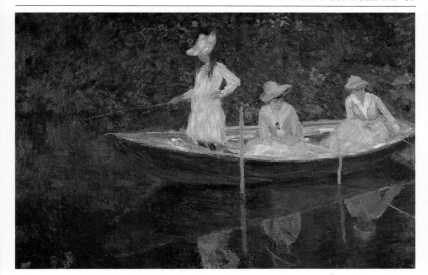

'You alone, with your name and authority, can break down the doors: that is, if they can be broken down.'

This campaign met opposition from Antonin Proust, formerly the Minister for Fine Arts. 'This Proust is a fine ass', wrote Monet to Morisot on 22 January 1890. 'I will tell him as much in a letter, and once war has been declared, we shall fight to the finish.' Monet finally succeeded in forcing the State's acceptance of *Olympia* for the Musée du Luxembourg; the painting was not moved to the Louvre until 1907, following Georges Clemenceau's intervention.

Monet now returned to his easel. On 11 July he wrote to Morisot: 'This devilish painting is making me sweat blood I might have expected as much, after all that time doing nothing.'

'I am yearning for Giverny'

While he was travelling, Giverny was constantly in Monet's mind. He thought of his garden, of his sons Jean and Michel, of his mistress Alice, and of the Hoschedé children. 'I shall be happy to come back and resume my life in the country. It seems to me I shall derive deep pleasure from painting there' (letter to Alice,

Several works by Monet show the Hoschedé girls boating on the Epte: here (above, left) *Study of a Boat* from a sketchbook, and (above) *Boat at Giverny* (c. 1887), named by the painter, after the boat itself, *In the 'Norvégienne'*. The river mirrors the figures. Germaine (standing), Suzanne and Blanche stand out against the foliage as if in a tapestry. The vegetation is even more commanding in another canvas created at the same time, from which the sky is once again absent; here *The Boat* (left) is empty, placed in one corner of the frame to leave more room for the water plants.

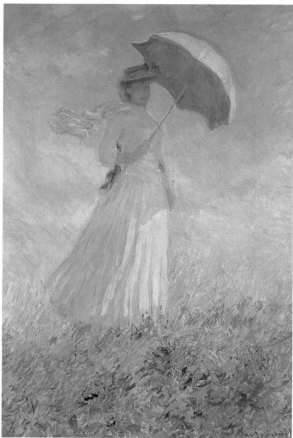

Bordighera, 12 February 1884). Monet's attachment to Giverny shines through in both his letters and his work. In the catalogue for the Monet–Rodin exhibition, Monet chose to group four canvases executed at Giverny (including *In the 'Norvégienne'*) under the title *Sketches of Figures in the Open Air*. They depicted the Hoschedé girls, whom he called 'my pretty models' in a letter to Morisot, 11 July 1890. These 'glorious Giverny figures', to use Octave Mirbeau's expression, evoke the ideal world that Monet had created for himself, uniting his private life and his painting.

At Vétheuil and on his travels, Monet abandoned figurative work. Around 1885, and for the last time, he attempted human figures in a landscape, handling the theme as a landscapist and Impressionist with particular emphasis on the luminous 'envelope' surrounding the model. In 1886 Suzanne Hoschedé appeared in these two versions of *Woman with Parasol Facing Right* (left) and *Facing Left* (opposite, top left). Monet here captures the fleeting moment before his eyes. The parasol breaks up the light; the floating scarf, the rippling of the dress, the bending grass suggest a windy day. The movement of the young woman, whom Monet has made almost featureless, corresponds with that of the clouds behind her. He called these two matching paintings *Sketches of Figures in the Open Air*.

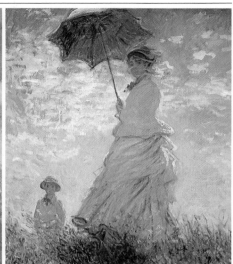

Mirbeau, who recognized this art of living untrammelled by any sort of artifice, laid special stress in his catalogue preface on Monet's domestic happiness: 'Paris, with its fevers, its struggles, its intrigues that sap one's will and destroy one's courage, could not suit a stubborn contemplative such as he, a man whose great passion is the life contained in things. He lives in the country, in the landscape of his choice, in the constant company of his models, and the open air is his studio. Here, far from the rumours, the côteries, the juries, the aesthetics and the ugly jealousies, he is producing some of the loveliest – and most noteworthy – works of our time.'

The sight of Suzanne outlined against the sky on a bank at the mouth of the Epte may have reminded Monet of a similar composition of Camille and Jean in 1875 (*The Promenade*, above). In any case, the two 1886 canvases evoke the memory of his dead wife; indeed, the painter seems to have been so moved by the resemblance that he could not bring himself to trace Suzanne's features.

Monet made a drawing after *Woman with Parasol Facing Left* to illustrate an article on himself by Mirbeau (7 March 1891, *L'Art dans les deux mondes*).

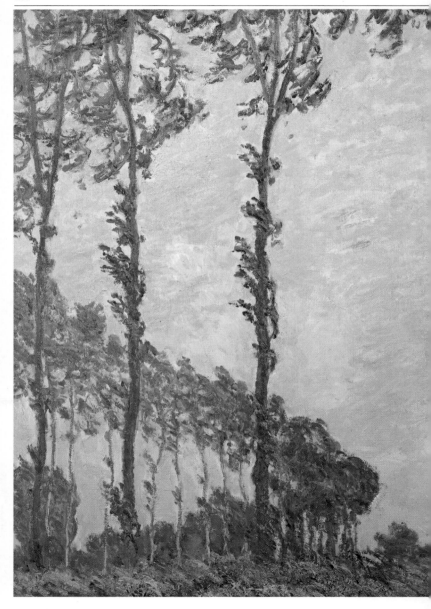

" **I** am working doggedly at a series of different effects. The farther I go, the more I realize that I must work very hard if I am to find what I am looking for: I am repelled by easy facility... I am more and more passionate about the need to convey what I feel, and pray that I might live for a while longer not too sunk in helplessness, because it seems I will yet make progress. "

Letter to Gustave Geffroy, 7 October 1890

CHAPTER 6

HAYSTACKS, POPLARS AND CATHEDRALS: THE SERIES PAINTINGS

I n this *Effect of Wind*, from the *Poplars* series (1891), the trees describe a decorative curve from the upper foreground to the lower background. Monet in 1897 (right).

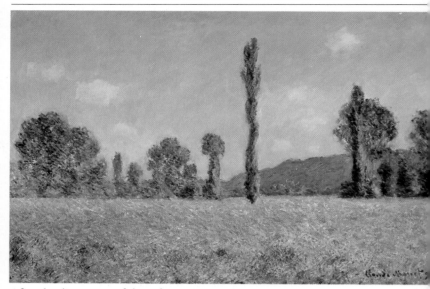

After the disruption of the *Olympia* campaign, Monet returned to work. His art now moved in a new direction, which had been on the cards for some time; from now on he only rarely painted isolated compositions, and the canvases he completed during the last six months of 1890 (*Poppy Fields* and *Haystacks*) all show that he was now steadily adhering to the idea of the series.

The *Haystacks*: A triumph to seal the reconciliation with Durand-Ruel

With its score or so of versions, the Giverny *Haystacks* series was the first of its kind. In early 1891 the Boussod–Valadon Gallery bought three canvases from Monet at 3000 francs each. The disagreements of 1888 were now forgotten, and the artist's relations with Durand-Ruel were back on a sound footing. On several occasions Monet wrote asking for money to enable him to complete his purchase of the house and garden at Giverny; on 15 December 1890, no doubt with an eye to his own interests, he confided that 'I am keeping some pictures for you, but have not managed to hold on to all of them. Valadon came to see me and bought several,

M onet painted different versions of *Poppy Fields* (1890–1, above, detail at right) in the meadows at Les Essarts, not far from his home. Here Clemenceau saw him working, 'in pursuit of those distillations of light, which changes the look of things from one moment to the next'. These poppies recall the canvas painted at Argenteuil in 1873, while the poplars, which blocked the horizon in *Ice Floes* (1880), are now seen in isolation, or else arranged curtainlike in the background.

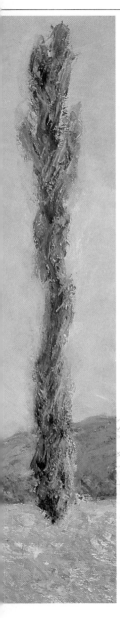

and I had a lot of trouble retaining the *Haystacks*.'

A letter from Pissarro confirms the instant success of the series. 'People want only Monets, it seems he can't paint enough to go round. The most amazing thing is they all want *Haystacks: Evening Effect* ... everything he does goes straight to America at prices of four, five and six thousand francs' (letter to Pissarro's son Lucien, 3 April 1891).

In May fifteen versions of the *Haystacks* were unveiled to the Paris public at Durand-Ruel's gallery, in a show entitled 'Recent Works by Claude Monet'. The catalogue carried a preface by Monet's friend Geffroy.

Pissarro was full of praise: 'These paintings seem to me very luminous, undoubtedly the work of a master; the colours are pretty rather than strong, the draughtsmanship fine but drifting, particularly in the backgrounds. Nevertheless, he's a very great artist!

"When I saw Monet facing his poppy field with his four canvases, changing his palette to keep pace with the moving sun, I had the impression of one involved in a study of light that grew in precision as his subject, supposedly unchanging, revealed to him a greater and greater degree of luminous mutability. It was an evolution in progress, the development of a new means of contemplation, feeling and expression: a revolution. Indeed this field of poppies with its three poplars marks the beginning of a new age in our history of sensation and expression."

Georges Clemenceau 'La Révolution de cathédrales', *La Justice* 20 May 1895

Preparatory pencil study for *Haystacks* (*c.* 1890).

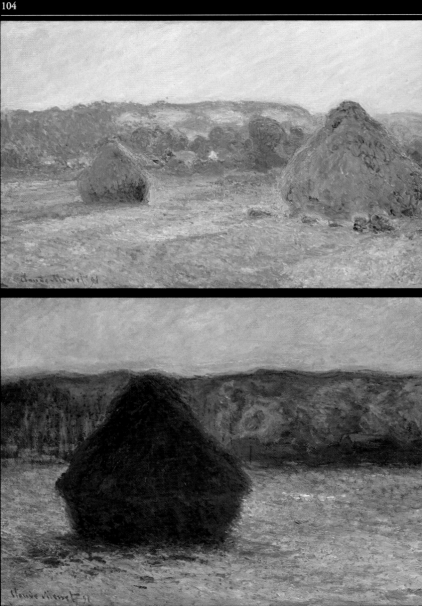

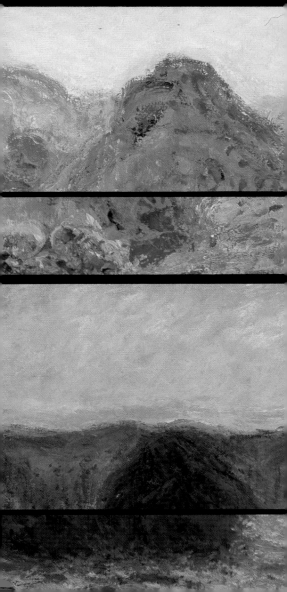

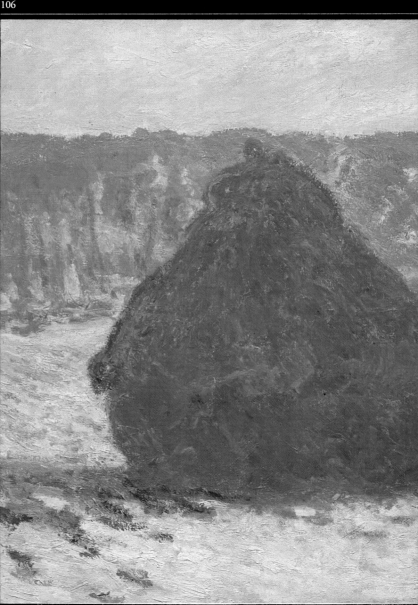

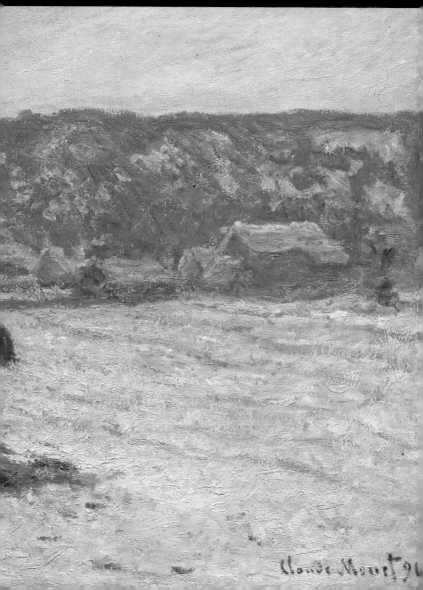

Claude Monet 94

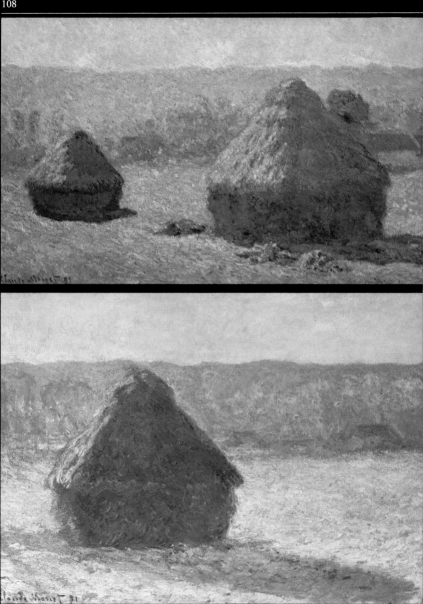

... from dawn till dusk

Monet wrote to Geffroy on 7 October 1890, while he was painting his *Haystacks, Late Summer, Evening Effect* (top left, details top right): 'At this time of year the sun goes down so fast that I can't follow it'. Then came *Haystack, Melting Snow, Sunset* (1890–1, bottom left, details bottom right). He captured ephemeral effects which vary with the different hours of the day, with the weather and with the seasons from the end of summer through to winter. All the versions of *Haystacks* reflect the position of the sun at a given instant. This is indicated by the direction and changing length of shadows cast on the ground, and their colour, which is often blue or mauve. Monet plays with the light and takes advantage of back-lighting.

"Monet, you have so astounded me lately with your *Haystacks* that I catch myself looking at the fields through the prism of your paintings; or rather they seem to impose themselves upon me in that way."

Mallarmé to Monet
July 1890

Needless to say it is a huge success, and is all so attractive that frankly I'm not surprised. The pictures breathe contentment' (5 May 1891).

Spring, summer and autumn 1891: *Poplars*

The next subject for his series method was poplars. Monet was in the habit of mooring his boat on the Ile aux Orties, at the edge of the marshes at Limetz, on the left bank of the River Epte above Giverny. It happened that while he was at work the common land of the marsh was put up for sale by auction. Monet, to avert the felling of the poplars before he had finished his paintings, did not hesitate. On 8 October 1891 he produced cash for the timber merchant who had acquired the land.

Like the *Haystacks*, this series of twenty compositions was an instant success. In January 1892 Maurice Joyant, who had replaced Théo van Gogh at Boussod–Valadon, bought some of the canvases and mounted a small exhibition of them at the Boulevard Montmartre gallery. In March Durand-Ruel showed fifteen versions of the *Poplars* (he himself had bought seven at 4000 francs apiece). This was the first time that a series had been exhibited as a composite work. The public was enchanted. 'I am very pleased with your news of my exhibition', Monet wrote to

Durand-Ruel on 22 March. 'I have it from several authorities that the effect has been considerable.'

In the same letter he once again declined to sell his work only through Durand-Ruel: 'I think it absolutely damaging and bad for an artist to sell to one dealer only.' And then he makes certain conditions which hint at his new-found wealth: 'From now on, I no longer wish to sell my paintings in advance; I want to finish them first, without hurrying, and I want to wait a while before deciding which ones I will sell.'

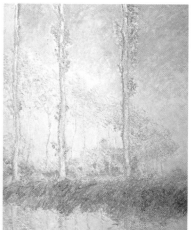

Alice Hoschedé becomes Madame Monet

The growing importance of Monet's attachment to Alice Hoschedé through the eighties is clear from the daily letters he wrote to her

Poplars, previously kept in the background of *Poppy Fields* and sometimes of *Haystacks*, now became a separate subject for Monet, which he studied in different lights and seasons. For his *Poplars, Three Pink Trees, Autumn* (1891, below, details at left) his palette was predominantly pink. He also played with the winding course of the Epte, edged by the poplars, to execute from his boat a series of rhythmical, decorative compositions built on curving lines and balanced by the straight, vertical treetrunks. All this expresses Monet's sense of space and his skill in the grading of planes. Here the three trees in the foreground both reflect in the river and rise into the sky. Above all, Monet uses a vertical format to emphasize the soaring lines and elegant shapes of his poplars. To his *Haystacks*, which are at one with the earth, he opposes the *Poplars*, which stand against the sky.

"What fine things, those three arrangements of poplars in the evening; how painterly, and how ornamental."
Letter from Pissarro to Monet
9 March 1892

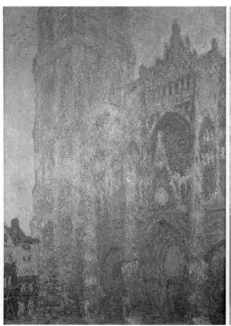
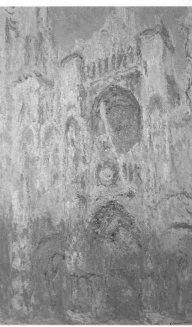

while on his travels. From Bordighera: 'My heart is always, always at Giverny ... you and my children are my entire life ... there is no happiness for me except with you' (26 January and 1 February 1884). From Antibes: 'You have in me a heart that loves you, someone you can always count on' (26 January 1888). And from Fresselines: 'Art and yourself are my life, my sole concern' (28 April 1889). One year after the death of Ernest Hoschedé, Monet put an end to the ambiguity that had surrounded his domestic life for over a decade by marrying Alice on 16 July 1892. Four days later he gave away his step-daughter Suzanne Hoschedé, the model for his *Woman with Parasol*, at the church in Giverny.

'This devil of a cathedral – how hard it is to paint!' (letter to Alice Monet, 22 February 1893)

Monet's series method was finally systematized with his *Cathedrals*, when he placed his easel opposite the west

The *Cathedrals* series is the most spectacular demonstration of Monet's will to convey immediacy in his paintings. His many versions of the subject correspond to his growing sensitivity to atmospheric variations. In contrast to *Haystacks* and *Poplars*, the cathedral motif is always the same and is viewed from more or less the same angle, which makes the changing forms under different light conditions all the more striking.

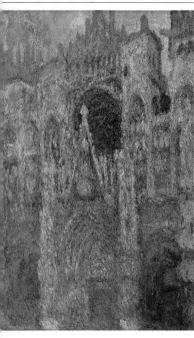
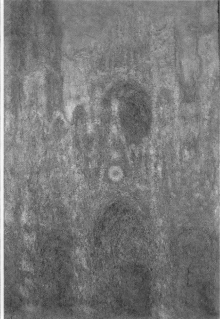

facade of the cathedral at Rouen. Though all these pictures are dated 1894, they were in fact done in two separate campaigns, in 1892 and 1893 (in both cases between February and mid-April), painted from three slightly different angles, then completed at Monet's Giverny studio. The artist's letters to his wife reveal his way of working and his determination to dominate this subject, of which he produced no fewer than thirty versions. 'Every day I add something and come unawares on some new aspect that I hadn't been able to see previously. How hard it is, yet it is working out ... I am broken, I cannot work any more ... I had a night filled with bad dreams: the Cathedral was collapsing on me, it seemed to be blue or pink or yellow' (3 April 1892).

Fully aware of the value and originality of this series, Monet treated Durand-Ruel to a shameful bout of blackmail, by dealing at the same time with Boussod–Valadon and with Maurice Joyant. He

From left to right, *Rouen Cathedral, the Portal and the Tour Saint-Romain: Morning Effect, Harmony in White; Sun Effect, End of the Day; Morning Sunlight, Harmony in Blue; Symphony in Grey and Pink* (1892–4). The architecture is not studied for itself, but only as a vehicle for pictorial research. To suggest the stone of the facade, Monet uses a rough paint surface which catches the light and imitates the shimmering effect of the sun.

demanded 15,000 francs for each canvas, but finally settled for 12,000. Twenty versions of the *Cathedrals* were displayed at the exhibition of Monet's recent works at Durand-Ruel's gallery in May 1895. Their importance was not missed by contemporary painters and writers. In his *Journal*, the painter Paul Signac cites 'those marvellously executed walls'. Pissarro acknowledges the interest of the series: 'I find in it that superb unity which I myself have sought for so long' (letter to Lucien Pissarro, 1 June 1895). Among the eulogies that appeared in the press, the one to which Monet himself paid most attention was a long article by Georges Clemenceau, which was published in *La Justice* (20 May 1895) under the impressive title of 'La Révolution de cathédrales'.

'Absolutely astonishing' snow effects

For two months during the winter of 1894–5, Monet had stayed near the village of Sandviken, 15 kilometres from Kristiania (now Oslo), the capital of Norway. In the midst of this 'white immensity', Mount Kolsaas inspired him to undertake another series: 'It is impossible to conceive of lovelier effects than there are here. I mean the snow effects, which are absolutely astonishing, but unbelievably difficult' (letter to his step-daughter Blanche Hoschedé, 1 March 1895). At the end of his stay, Monet was congratulated by several artists, notably the Norwegian landscapist Fritz Thaulow and Prince Eugen of Sweden, himself a painter. In May, alongside the twenty *Cathedrals,* the Paris public was confronted at Durand-Ruel's by no fewer than eight Norwegian landscapes.

A series of scenes from Monet's youth

At the age of fifty-five, Monet felt impelled to go back to the landscapes of his early life. In the winters of 1896 and 1897 he returned to Pourville and Varengeville. During the latter period he executed ten paintings of a former customs look-out on the cliff-top at Petit-Ailly. This served as his *Fisherman's House at Varengeville*, according to the title that Monet gave to some of the works in which it appears. The 'little house' is shown at

Supplément au Journal

Le G

A LA GALERIE

EXPOSITION

"I went into Durand-Ruel's to gaze at leisure on the studies of Rouen Cathedral that had so delighted me in the Giverny studio, and now I have brought that many-faceted cathedral away with me, without knowing how. I can't get rid of it ... it obsesses me With twenty canvases of judiciously chosen effects, the painter has let us understand that he could have, indeed should have, done fifty, a hundred, a thousand more, as many paintings as there might be seconds in his life, should his life last as long as that stone monument. Monet's prophetic eye scans the future and guides our visual evolution, rendering our perception of the universe more penetrating and subtle than before."
Georges Clemenceau
'La Révolution de cathédrales', 1895

LE GAULOIS du 16 Juin 1898

aulois

GEORGES PETIT

CLAUDE MONET

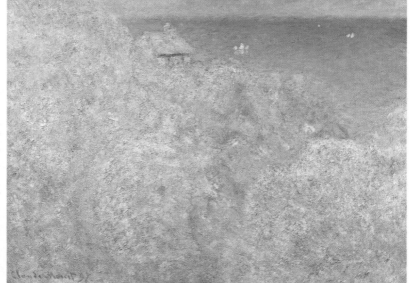

different times of day, according to the series principle. On 1 June 1898 a special exhibition was mounted at the Georges Petit Gallery, featuring these Normandy paintings along with some canvases done at Giverny, *Morning on the Seine*.

The works painted at Vétheuil in 1900 also demonstrate Monet's determination to apply a technique he had recently perfected to subjects connected with his past. He continued to work there right up to the exhibition of 'Recent Works by Pissarro and a New

Fifteen years after *The Fisherman's House, Varengeville* (1882, top), this *Cliff at Varengeville* (1897) is freely interpreted with an even more luminous palette. Here Monet is clearly moving towards a decorative art that is close to abstract.

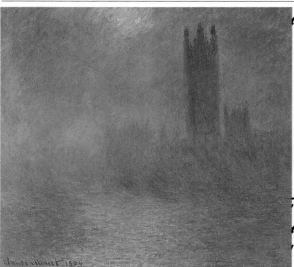

Series by Monet (Vétheuil)', which was mounted in February 1902 by the Bernheim-Jeune Gallery – a new dealer for Monet.

'Every day I find London more beautiful to paint' (letter to his step-daughter, and now daughter-in-law, Blanche Hoschedé-Monet, 4 March 1900)

Another pilgrimage to a place he had known in his youth took Monet back to London on three occasions, in autumn 1899, February 1900 and from February to April 1901. Here he pursued an old ambition to 'paint some effects of mist on the Thames' (letter to Duret, 25 October 1887). The Houses of Parliament and the Charing Cross and Waterloo bridges captured his exclusive attention. The two bridges he painted from his room at the Savoy Hotel, and Parliament from Saint Thomas' Hospital. But what interested Monet most of all was the prospect of painting the special effect of fog in the city, what he called 'a superb mist' in a letter to Alice, 24 February 1900.

Faithful to his chosen method, Monet finished his hundred-odd London paintings in his Giverny

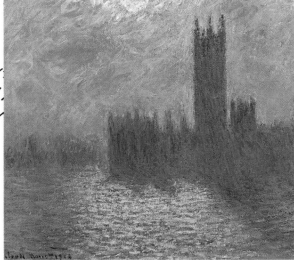

studio, and repeated the experience pioneered by his *Poplars*; thirty-seven of these canvases were exhibited on their own at Durand-Ruel's gallery in May and June 1904 under the title of 'Series of Views of the Thames at London (from 1900 to 1904)'. The Thames, in fact, constitutes the link between his three sub-series of London motifs.

'I am lost in admiration for Venice' (letter to Durand-Ruel, 19 October 1908)

After this temporary phase of nostalgia, Monet turned once again to new landscapes. From October to December 1908 (he was now sixty-eight) he took Alice on the last major journey of his life – to Venice, the city of painters *par excellence*. As in London, he continued his

In *The Houses of Parliament: Sun Shining through a Gap in the Fog* (opposite) and *Stormy Sky* (above), both completed in 1904, Monet took great liberties with his subject by flattening, narrowing and vertically elongating the Neo-Gothic architecture; the building rises up like a phantom. The paint tones recall *Impression, Sunrise*, and the atmosphere evokes the visions of Turner and James Abbott McNeill Whistler. Fragmented brushwork lends the Thames itself a stronger presence than the evanescent Parliament.

List made out by Monet for his 1904 exhibition at Durand-Ruel's gallery (centre).

struggle to marry architecture, water and light: the stone of the buildings – in this case, the palaces – being sacrificed to the study of 'this unique light' (letter to Geffroy, 7 December 1908). Seeming to care nothing for Venice's venerable past, Monet concentrated on its 'magical, fairylike aspect', which had likewise fascinated Turner. For this reason his canvases have been compared to the timeless Venice of the imagination evoked by Proust in his *Remembrance of Things Past*: 'We watched the double row of palaces between which we passed reflect the light and angle of the sun upon their rosy surfaces, and alter with them' (*The Sweet Cheat Gone*).

Like his *Views of the Thames*, Monet's Venetian canvases were completed at Giverny in the years that followed. In May and June 1912, the Bernheim-Jeune Gallery presented twenty-nine *Views of Venice* divided into several groups (the Grand Canal, San Giorgio Maggiore and various palaces). At the same time an illustrated album entitled *The Venice of Claude Monet* was published, with a study by Mirbeau. On 31 May Signac voiced his admiration to the painter: 'These *Venice* pictures, in which everything unites as the expression of your will, in which no detail runs counter to emotion ... I admire them as the highest incarnation of your art.'

'I pine for Giverny. Everything must be so beautiful there in this glorious weather' (letter to Alice, Rouen, 13 April 1892)

Throughout these years, Monet never ceased to think

CLAUDE MONET

"Venise"

Neuf reproductions de Tableaux
(en fac-similé et huit phototypies)
Avec une Préface
par
OCTAVE MIRBEAU

BERNHEIM-JEUNE & Cⁱᵉ
Experts près la Cour d'Appel
15, Rue Richepanse
25, Boulevard de la Madeleine
36, Avenue de l'Opéra
PARIS

The Doges' Palace from San Giorgio Maggiore (1908) illustrates Monet's sense of space: in the foreground, the quay of the island of San Giorgio projects into the lagoon, while the facades of Venice rise from the very surface of the water. Above left, a pencil sketch of the Palazzo Dario.

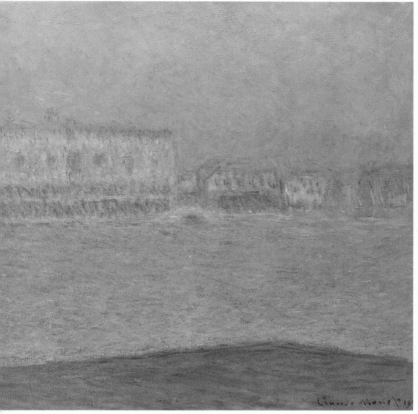

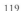

of Giverny. As the owner of the house since 1890, he had made the garden more beautiful each year, mingling his love for it with his love for his art and his family, particularly Alice. He sent home plant varieties from the Rouen botanical gardens and promised to bring his children 'some plant specimens' of the Nordic lands.

He often dispatched recommendations about flowers to Alice; from Pourville he wrote to her that he dreamed of what he would do at Giverny when the garden was in flower (18 March 1896).

At the end of his life, Monet hardly set foot outside Giverny, which became his sole source of inspiration.

"My enthusiasm for Venice continues to grow, and it saddens me that the moment is coming when I must leave this unique light. It's so beautiful. But I have had delicious moments here, almost forgetting that I am the old man that I am."

Letter to
Gustave Geffroy
7 December 1908

"Here and there, on the surface, there floated, blushing like a strawberry, the scarlet heart of a lily set in a ring of white petals ... a little further again, were others pressed close together in a floating flower-bed, as though pansies had flown out of a garden like butterflies and were hovering with blue and burnished wings over the transparent shadowiness of this watery border; this skylike border ..."

Marcel Proust, *Swann's Way*, 1913

CHAPTER 7

WATER-LILIES: MONET'S FINAL MESSAGE

An 'effect of twilight' pervades these *Water-lilies* (1907), as a flow of light illumines the lily pads. At right, Monet photographed by playwright Sacha Guitry, *c.* 1920.

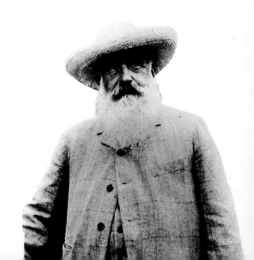

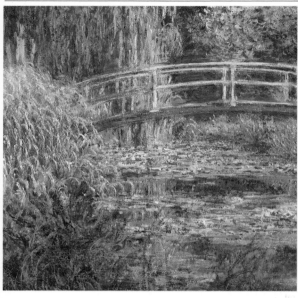

A pool 'with a view to growing aquatic plants, a thing of pleasure, to delight the eyes, and also a source of subjects for painting' (letter from Monet to the Prefect of the Department of the Eure, 17 March and 17 July 1893)

After 1890 Monet built himself a new studio. While continuing with the laying out of his flower garden, he created a second space, which he called his 'jardin d'eau', or water garden. This broad pool, crossed by a bridge, is a reminder of the painter's interest in Japanese art. Though it emerges in Monet's paintings from 1895 onwards, it is really from the year 1898 that he produced several paintings of it, mostly dated 1899 or 1900. As in his contemporary *Views of Vétheuil*, the format for these different compositions is nearly square.

Monet entitled these paintings *Nymphéas* – the scientific name for the variety of white water-lily that he grew in Giverny, to which in 1885 Mallarmé dedicated a prose poem. Monet returned to the theme of his Japanese bridge in the 1920s, but by that time its airy

Among the ten or so versions of *The Water-lily Pool* exhibited at Durand-Ruel's gallery in 1900 was this *Harmony in Pink* (above left; above, detail from an autochrome, *c.* 1917, by Etienne Clémentel – autochrome was a colour photographic process invented by the Lumière brothers). The background of the painting is filled by willows, against which the bridge (perhaps inspired by the Japanese prints of Hokusai) stands out boldly. Then the artist lowers his eyes to concentrate on the water surface, as in his *Water-lilies* painted 1907 (far right).

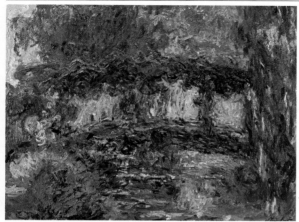

"I have to work and would wish to paint everything before my sight goes."

Letter to
Joseph Durand-Ruel
7 July 1922

With the onset of cataracts, Monet felt a feverish compulsion to record the world of Giverny. His perception of colour was altered, and the canvases are hard to date just before or after his eye operations. *The Japanese Bridge* (left, *c.* 1923) shows the upper arch covered by the wistaria he loved.

"A word to let you know the wistaria is nearly out, in a few days it will be splendid, you must come."

Letter to Clemenceau
16 May 1922

lightness had been obscured beneath a mass of vegetation and hanging wistaria.

At the end of 1900, about ten versions of the *Water-lily Pool* were exhibited at the Durand-Ruel Gallery, among twenty-five recent works by Monet.

'The Water-lilies, A Series of Water-Landscapes'

This was the title chosen by Monet himself for the 1909 Durand-Ruel exhibition of forty-eight of his works painted between 1903 and 1908: an 'out-of-the-ordinary exhibition', in the painter's own words to his dealer (28 January 1909). After 1904 the landscape surrounding the pool is reduced in Monet's paintings to a narrow strip in the upper area of the canvas, then gradually disappears altogether, leaving the lilies to occupy the whole frame. 'You should know I am immersed in work. These landscapes of water and reflection have become my obsession. It is beyond my old man's strength, yet I still want to convey what I feel. I have destroyed

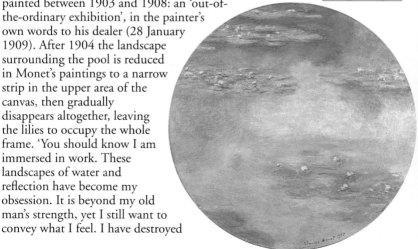

some ... but then I start again afresh' (letter to Geffroy, 11 August 1908).

Monet's 1909 exhibition was a great success, hailed by France's most prominent critics, including Geffroy, Romain Rolland, Remy de Gourmont, Lucien Descaves and Roger Marx.

Official success and recognition

From this time on, Monet's works appeared in many exhibitions abroad, in Brussels (at the Libre Esthétique gallery), London, Berlin, Stockholm, Dresden, Venice, and of course in the United States, where, thanks to Durand-Ruel, the painter Theodore Robinson and the collector Mrs Potter Palmer, Monet's reputation was now firmly established. At the same time Giverny became a shrine for foreign visitors, among them Japanese, Russians (the collector Sergei Shchukin) and Americans (John Singer Sargent, Robinson, and the young student Lilla Cabot Perry, who later wrote an account of her interviews with the master).

Apart from his old friends (Sisley, Pissarro, Morisot, Mallarmé, Rodin, Renoir and even Cézanne) and his intimates (Geffroy, Mirbeau and Clemenceau), many new admirers came to Giverny: the painters Jacques-Emile Blanche and Pierre Bonnard, Sacha Guitry, the publisher Paul Gallimard, and various members of the Goncourt Academy. Finally, however, his antipathy to receiving journalists – a few meetings were granted to François Thiébault-Sisson – and his 'great age' led

Monet's self-portrait (1917) was done with touches of juxtaposed colour. He gave it to Clemenceau, who presented it to the Louvre in 1927.

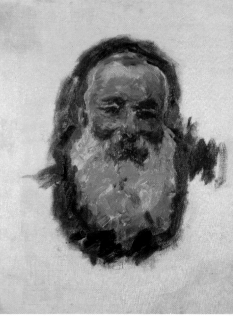

"Here is the address of the rose-grower ... also the names of the roses you noticed. The climber on the front of the house is *Crimson Rambler* and the standard is *Virago*."
Letter to G. and J. Bernheim-Jeune 2 July 1909

Monet to prefer work and solitude to inconvenient visitors, and to reserve his rare moments of repose for a small group of old friends. Meanwhile Durand-Ruel, aided by his sons and still unable to obtain exclusive rights on Monet's paintings, was forced to reach an agreement with the Bernheim-Jeune brothers, who were also regular visitors to Giverny, to buy and exhibit Monet's works. His prices were now gigantic (40,000 to 50,000 francs for certain canvases in 1924); the artist himself was stunned by the sums they were fetching.

The time had clearly come for official recognition. Eight paintings from the Caillebotte collection entered the Musée du Luxembourg in 1896. These were joined in 1906 by works from the Moreau-Nélaton collection, in 1907 by *Rouen Cathedral, Harmony in Brown* and in 1921 by *Women in the Garden* – the same work that had been rejected by the Salon over fifty years before. The latter two paintings were bought directly by the French State, and all were moved to the Louvre a few years later. Monet was also represented in several provincial museums.

'Water, lilies, plants, but spread over a wide surface' (letter to Raymond Köchlin, 15 January 1915)

During the First World War Monet built himself a top-lit studio, so as to work on his *Grandes Décorations de nymphéas*. Just after the 1918 armistice he proposed to Clemenceau the gift of two panels to the State, in celebration of France's victory. After lengthy discussions, an act of donation was signed on 12 April 1922, which established that eight compositions would be hung in

This sketch and list of flowers from the hand of Monet show his interest in flowers, which he ordered from the growers Truffaut and Vilmorin. He was also an avid reader of gardening magazines.

"I am currently very busy with my gardeners, with major works in view."

Letter to the ophthalmologist Doctor Coutela 13 October 1923

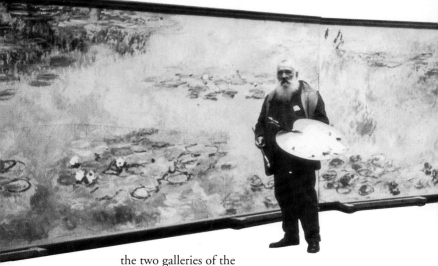

the two galleries of the Orangerie in the Tuileries. The works had been painted specifically to fit their oval shape.

In the years that followed, Clemenceau gave Monet tireless encouragement, though the artist was frequently tempted to give up this huge enterprise because he feared the loss of what was most precious to him – his sight. He was suffering from the onset of cataracts, and he refused to be operated on for this affliction until January 1923, fearing that an operation might rob him of his sight altogether.

'How terrible it is to reach the end of one's life'

This observation, made in a letter from Monet to Geffroy on 7 February 1899 just after the deaths of Sisley and Suzanne Hoschedé-Butler (*Woman with Parasol*), was to become a constant refrain in his correspondence, as the painter saw his old friends disappearing one by one: Morisot (1895), Mallarmé (1898), Pissarro (1903), Mirbeau and Degas (1917), Renoir (1919 – 'now I am the last survivor of the group', wrote Monet sadly on 8 December); then Paul Durand-Ruel (1922) and Geffroy (1926). Above all, Monet grieved for his 'adored companion' of over thirty years, Alice, who died in 1911, and his elder son Jean, who succumbed to illness in 1914.

In the early 1920s Monet posed for this photograph in front of *Morning*. Palette and brush in hand, he stands in his last studio, which was specially built for his work on the *Grandes Décorations* (following pages: *Morning, no. 1*, and *The Clouds*), later housed in the Orangerie. At this time Monet's life at Giverny was entirely governed by the daylight hours; he only received visitors when he was unable to work in the studio.

"I am well, though very old, and I have my sight back at last, to my great joy. So I have worked joyfully all summer, with more zeal than ever."

Letter to
Paul César Helleu
29 October 1925

'What a sad end
for me', he wrote to Geffroy
on 19 November 1919. But then, after his
operation, he partly regained his sight and sought
consolation in his work: 'I am working as never before,
I am happy with what I am doing, and if the new glasses
are better still, I ask only to live until I'm a hundred'
(letter to André Barbier, 17 July 1925).

Watched over by the woman Clemenceau once called
'the angel', Blanche Hoschedé-Monet (the widow of his
son Jean), Monet died on 5 December 1926 at the age
of eighty-six.

Because he had refused to deliver his *Grandes
Décorations* during his lifetime, these were now placed
in the Orangerie in accordance with his will; the
inauguration took place on 17 May 1927. The complete
ensemble of *Water-lilies* represents the final message of
the master of Giverny, who expresses himself in a form
so innovative as to be close to abstract. Through this
legacy, the former leader of the Impressionists stands
revealed as a true man of the twentieth century, who was
recognized as such by the artists of the avant-garde.

In his last years, Monet
told Clemenceau,
'While you,
philosophically, seek the
world in the self, I
merely apply my effort
to a maximum of
appearances, in close
correlation to unknown
realities. When one is on
the plane of concordant
appearances, one cannot
be too far from reality,
or at least from what we
are capable of knowing
about it. I have done
nothing but look at
what the universe has
shown to me, so as to
bear witness to it with
my brush.'
Claude Monet
1928

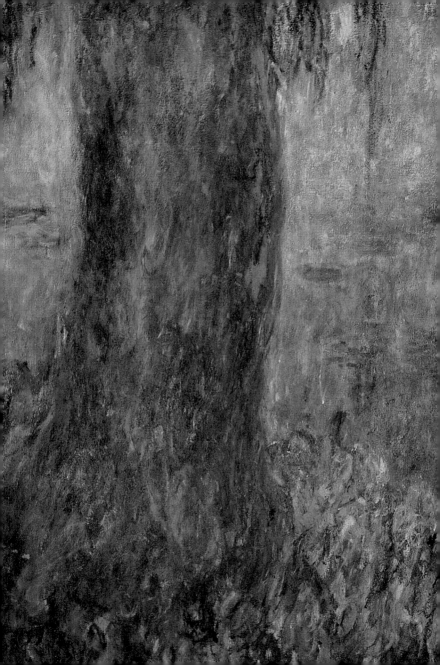

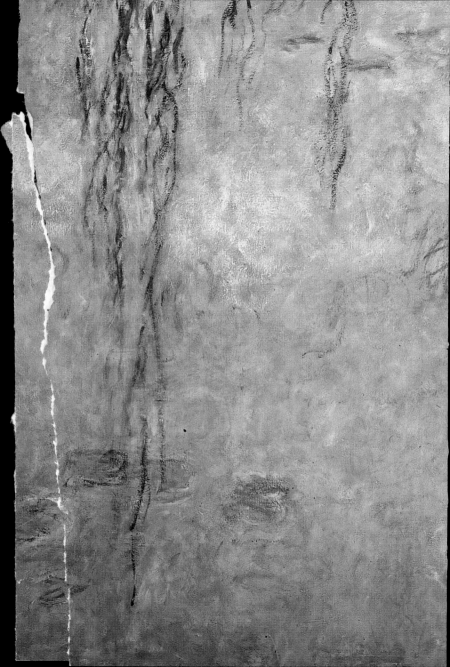

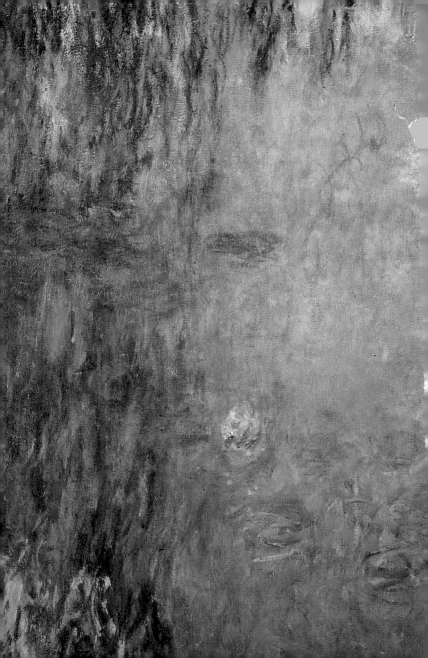

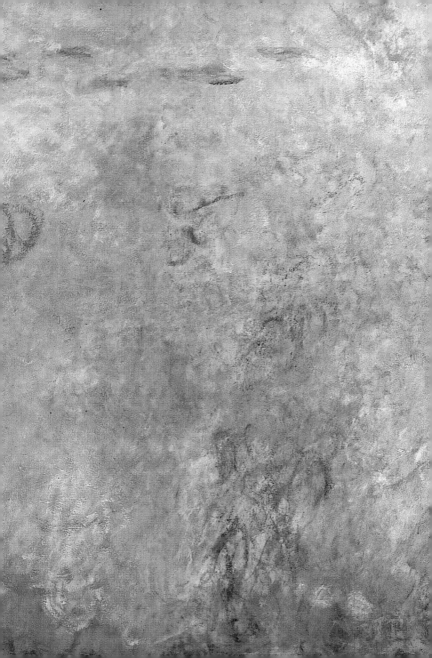

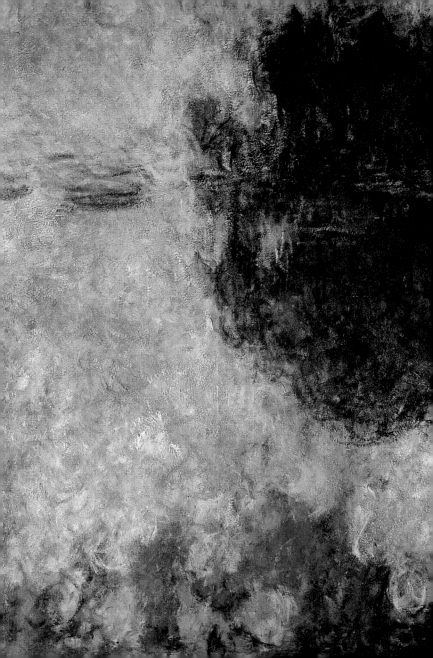

DOCUMENTS

Monet and the artists of his time

Monet's long life is amply documented by a correspondence that reveals his character and places him squarely within the context of his own era. With his friends, he formed deep relationships that were completely free of affectation; he applied the same rule to fellow artists, through mutual gifts of paintings, messages of congratulation, and exchanges of views about the talents of contemporaries. Sometimes both sides of the correspondence have survived, so that we have in effect dialogues between him and his friends.

Monet and Daubigny

At the 1859 Salon, the young Monet admired the works of the painters Troyon and Daubigny. The latter was to introduce him to Durand-Ruel in London, 1870–1.

Everything you have heard said of Daubigny and me is true, and I have reason to be very grateful to him. When he met me in London during the Commune, I was in serious straits; he was enthusiastic about some of my Thames studies and he put me in touch with Monsieur Durand-Ruel, thereby saving me and several of my friends from dying of hunger. Help like that one doesn't forget. Another thing since that time has affected me deeply: Daubigny's purchase of one of my Holland paintings at Durand-Ruel's. But most to his credit is the fact that he resigned as a member of the jury of the official Salon of the time, because it had so unjustly refused work by me and my friends.

> Monet to Etienne Moreau-Nélaton
> Giverny, 14 January 1925

Extract from Monet's address book.

Monet and Boudin

The man whom Corot called the 'King of the Skies', Eugène Boudin, was his first master – the second was Jongkind. Monet always acknowledged his deep debt to Boudin.

The only good painter of seascapes we have, Jongkind, has died for art. His is a worthy place for you to fill I hope you won't refuse me a little sketch of yours as a souvenir, and as to your advice, you know how much attention I pay to it.

Monet to Boudin
Paris, 20 February 1860

We were talking of Monet At a dealer's on the Rue Lafayette, there is a view of Paris by him which would be worthy of the great masters, if the details were on a par with the ensemble. That boy has what it takes.

Boudin to F. ('Père') Martin
Paris, 18 January 1869

You write to inform me of your marriage. Will you allow me to send these few lines in happy remembrance of time past? But first of all I want to congratulate you and Madame Monet, whom I had the pleasure of meeting in earlier days, when she entertained us artists so graciously and kindly.

For years now the hazards and necessities of life have kept us apart, but nonetheless I have shared in your efforts and your successes ... with interest I have followed you in your bold endeavours, even in your foolhardy ones, and watched them bring you fame and reputation. The times are long gone when we sallied forth to try our skills at landscape in the Rouelles valley, or along the coast of Sainte-Adresse, or at

Trouville and Honfleur – with Jongkind, our good, great, and much-mourned friend.

As I grow older I have but one regret, which is that among the souvenirs I have carefully kept for myself, I have not the smallest painting by you You who should be there on my wall to remind me of those early years, which I have to say were times of struggle, hardship and discouragement.

You owe me this souvenir I do not ask it of you for the purely venal reason that your paintings have increased in value.

Do as you think fit, my dear Monet, but believe that you would give me the greatest pleasure by remembering this. You have taken possession of your destiny. You have outlived struggle and difficulty. Do this soon, for I am growing older with every day that passes.

Boudin to Monet
Deauville, 28 July 1892

I was very touched and very flattered by your request. I am determined to give you something that will be worthy of you.

You know the affection I have always cherished for you, and the gratitude. I have not forgotten that you were the one who first taught me to see, and to understand what I saw.

Like you, I have often thought of those early days, and of those delightful rambles with Jongkind and Courbet. So I am very happy that you have not forgotten either.

I very much hope to come and shake your hand this winter, and talk again of those good old times.

Your old friend.

Monet to Boudin
Giverny, 22 August 1892

Monet and Bazille

Bazille, a companion at Gleyre's studio and a generous admirer, was the great friend of Monet's youth. The bond between them was shattered by Bazille's death in 1870.

I have spent eight days at the little village of Chailly, near the forest of Fontainebleau. I was with my friend Monet, from Le Havre, who is rather good at landscapes. He gave me some tips that have helped me a lot.

Bazille to his mother
1863

Maître Courbet paid us a visit to see Monet's *Picnic*, which delighted him. In fact, over twenty painters have come to see it and all of them admire it greatly, although it is far from finished (naturally I say nothing of my own work). This painting is bound to cause a furore at the Exhibition.

Bazille to his brother Marc
December 1865

At the moment we are all signing a petition demanding an exhibition of the paintings rejected by the Salon. The petition is supported by every Paris painter who is any good. However, it will come to nothing … so we have decided to rent a big studio each year in which we will exhibit our work. We will invite all the painters we like to send in paintings. Courbet, Corot, Diaz, Daubigny and plenty more have promised to send things, and very much approve of our idea. With them and Monet, who is the best of all, we are certain of success. You'll see, people will be talking of us.

Bazille to his mother
1867

Frédéric Bazille.

I know better than anyone the true value of the painting [*Women in the Garden*] that I have bought from you, and I very much regret not being rich enough to pay you more for it.

Bazille to Monet
2 January 1868

Monet and Manet

Although he preferred to exhibit his work at the 1874 Salon rather than join the First Impressionist Exhibition, Manet was very close to Monet, to whom he often gave financial assistance. By putting himself at the head of the subscription organized to buy Olympia *for the Musée du Luxembourg in 1890, Monet showed his loyalty to his old friend.*

My dear Manet,
I often think of you and of how much I owe you, and it is really most kind not

Edouard Manet.

Yes, poor Manet was very fond of me, but we return that fondness in equal measure, and I am exasperated by the silence and unjustness being shown by all, about his memory and his great talent.

Monet to Mallarmé
19 June 1888

Monsieur le Ministre,
In the name of a group of subscribers, I have the honour to present to the State *Olympia* by Edouard Manet.

We are convinced that in this we speak for and represent many other artists, writers and art-lovers, who have long since acknowledged the important place in this century's history which belongs to this painter, who has been so prematurely lost to his art and his country.

In the view of the vast majority of those who take an interest in French painting, the role of Edouard Manet has been both positive and decisive. He not only played a vital individual role; he was also the personification of a great and fruitful development in our art.

It seems to us preposterous that a life's work of such importance has still found no place in our national collections, that the master has not gained entry where his disciples are already well established. Moreover, we view with disquiet the incessant shiftings of the art market, the growing competition from America in the purchasing of our work, and the departure, so easily avoidable, of so many works of art which should be the joy and glory of France. Our wish is to preserve for the nation one of Edouard Manet's most characteristic works, in which he appears in the fullness of triumph, a master of his vision and his art.

to have asked for that money back, which you must badly need

I am very glad to hear that your paintings are so successful. Apparently you have done some marvellous things.

Monet to Manet
Vétheuil, 14 May 1879

I have this minute heard the terrible news that poor Manet is dead. His brother can count on me as a pall-bearer. I must go to Paris tomorrow and have a black suit made.

Monet to Durand-Ruel
Giverny, 1 May 1883

We therefore entrust *Olympia* to your care, Monsieur le Ministre. It is our desire to see it take its rightful place in the Louvre, among its contemporaries of the French School. Should regulations stand in the way of its immediate entry, we believe that the Musée du Luxembourg is the obvious choice to receive *Olympia*, and to keep it until the question can be reconsidered.

Monet to Armand Fallières
7 February 1890

Monet and Morisot

With his strong sensitivity to the human qualities and talent of the leading female Impressionist, Monet admired Berthe Morisot, who was married to Manet's brother Eugène, as a woman of charm and a true artist.

I am far from Paris. I cannot come to admire your work at Petit's; but nearly every day I have letters telling of your successes, and I want to congratulate you on the fact. I have a bow window here overlooking the sea, and a garden that is one great sunburst of flowers. You would do wonders with it!

Morisot to Monet
Jersey, June 1886

It is very kind of you to worry about me, but the truth is that bad weather and age are the only causes of my infirmities. I have become a wheezing old lady. You are charmingly modest, but I know you

Berthe Morisot photographed in her studio.

are in brilliant form and are doing some delightful things.

We often talk of you with Mallarmé, who is one of our faithful friends, and a great friend to you too.

Morisot to Monet
14 March 1888

You must think me very forgetful. I wanted to come and see you, and to tell you how lovely I thought your paintings at Durand's were, but I have been very busy here, only coming to Paris *en passant* for an hour or two; and also I hoped, hearing you were with Mallarmé, that you would come to Giverny.

Have the Goupils at least informed you that they are exhibiting the ten paintings I sold to them? I would be glad to know what you feel about them.

Monet to Morisot
Giverny, early June 1888

Thank you for your kind letter, and for the kind things you say about my wretched paintings at Durand's. I am all the more touched because the show, as you know, is a complete flop.

You have really won over the public, mulish as it is. The people one sees at Goupil's are full of admiration, and I think it rather brazen of you to ask my impression of the show: you know perfectly well it's stunning.

I saw Mallarmé on Thursday. I should be amazed if that charming man doesn't send you a fine letter to express his admiration. We are both very much inclined to come and see you at Giverny.

Morisot to Monet
June 1888

I deeply regret not having seen her one last time before I left,* and it is a great grief to me to think she is no more; she

was so intelligent, so talented …. It is really very, very sad and hard to see all one's friends dying so soon. Alas, how many of our little group remain today?

Monet to Alice Monet
Sandviken, 10 March 1895

* Berthe Morisot died in March 1895

Monet and Cézanne

In his bedroom at Giverny Monet had several paintings by Cézanne, among them The Negro Scipio. *Even the painter who*

Cézanne with his painting *The Bathers*.

wanted to 'go beyond Impressionism' was forced to acknowledge the superiority of Monet's eye.

I agree to Wednesday.* I hope Cézanne will still be here and will join us, but he is so cranky and so shy of new faces that I am afraid he will be absent, despite the yearning he has to meet you. What a shame it is that he has not had more support in his life! He is a real artist, but one who doubts himself overmuch. He needed his spirits raised, so he was most receptive to your article!

Monet to Geffroy
Giverny, 23 November 1894

* Monet invited Geffroy to Giverny to meet Cézanne at a lunch on 28 November 1894. The other guests were Mirbeau, Rodin and Clemenceau.

I want to tell you how glad I was of the moral support you gave me, which still serves to encourage me in my painting.

Cézanne to Monet
Aix, 6 July 1895

I am pursuing success through work. I distrust all living painters save Monet and Renoir.

Cézanne to Joachim Gasquet
Aix, 8 July 1902

I thought I told you during our talk that Monet was living at Giverny; I hope the artistic influence of this master will not fail to influence his entourage directly or indirectly, and will produce the necessary effect that it can and must have on a young artist who is eager to work.

Should you meet the master [Monet] whom we both so much admire, remember me to him. I don't think he cares much to be disturbed, but if you show sincerity he may unbend a little.

Cézanne to Charles Camoin
Aix, 13 September 1903

Monet and Pissarro

Though his temporary adherence to Neo-Impressionism led him to criticize Monet's work, Pissarro immediately understood the value of the 'series' paintings of the 1890s.

He [the critic Braquemond] also notices the coarse execution of some Monets, for instance a Dutch canvas* in which the paint is so thick that it adds an artificial light to that of the picture itself

Pissarro, self-portrait.

(you cannot conceive how unpleasant I find this) and what is more, allied with a thin, swept-over sky; no, I cannot go along with his approach to art.

Pissarro to his son Lucien
15 May 1887

* A version of *Tulip Fields* (Stedelijk Museum, Amsterdam) exhibited at the 'Sixth International Exhibition', at the Georges Petit Gallery, 1887.

I told you that what I saw of Monet's pictures did not appear to indicate progress; this view is more or less unanimous among the painters. Degas was one of the harshest critics; he considers them no more than commercial art. Moreover, he has always taken the view that Monet does nothing but fine decorations. But as Fénéon says, it's more vulgar than ever. Renoir thinks it a step backward and so does Durand's son, though it is true he is a rival dealer.

I met Monet at Durand's. I don't know, but he always seems a bit supercilious. I was reading an article in which he was criticized very foolishly, and for such stupid reasons that I brought it to his attention; there was equally stupid praise, too. We didn't speak of painting otherwise – there was no use, he wouldn't have understood me. After all, he may be right; each man must follow his own line as best he can!

Pissarro to his son Lucien
Paris, 10 July 1888

Yesterday Monet's exhibition* opened at Durand's. I went with one eye bandaged, so I saw Monet's marvellous *Sunsets* with only one eye.

They seemed to me filled with light, undoubtedly the work of a master. But since, for our own instruction, we must go beneath the surface, I asked myself what could be lacking. It's hard to make this out; the lack is certainly not one of exactness or harmony, more of execution, of a calmer, less ephemeral way of seeing. The colours are pretty rather than strong, the draughtsmanship fine but drifting, particularly in the backgrounds. Nevertheless he's a very great artist!

Of course it is a huge success, and so attractive that frankly I'm not surprised. The pictures breathe contentment.

Mirbeau told me about your woodcuts, which he thinks very good, and so does Monet.

Pissarro to his son Lucien
Paris, 5 May 1891

* Fifteen versions of *Haystacks* were shown at this exhibition.

I would be sorry if you did not get here before Monet's exhibition closes; his *Cathedrals* are going to be dispersed all over the place, and they should really be seen all together. The younger painters, and even some of Monet's admirers, bitterly oppose them. I am intrigued by his extraordinary mastery. Cézanne, whom I met yesterday at Durand's, agrees that it is the work of a determined, level-headed man, pursuing elusive effects and nuances that no other artist we know can match. Some artists think such research unnecessary, personally I think any research is justifiable if it is as deeply felt as this.

Pissarro to his son Lucien
Paris, 26 May 1895

You remember that Monet's *Cathedrals* were all done with a heavily veiled effect which lent the monument a certain mysterious charm.

Pissarro to his son Lucien
Rouen, 24 March 1896

Monet and Caillebotte

Monet and Caillebotte were united by a passion for painting and gardening. It was thanks to the 1894 bequest of Caillebotte that eight canvases by Monet entered the Musée du Luxembourg in 1896.

My dear friend,
Be sure and come on Monday, as we agreed, for all my irises will be in flower;

Monet in the garden at Giverny.

any later and some of them will be over. Here is the name of the Japanese plant which is coming to me from Belgium: *Crythrochaete*. Try to speak to M. Godefroy about it and give me some clues as to how I can best look after it.

Monet to Caillebotte
Giverny (undated)

My dear Martial,
I received the photographs of Gustave this morning, and they have given me great pleasure. Thank you so much for them and for having thought to send me the one of you both together.

I hope that everything is arranged with the [Ecole des] Beaux-Arts, and that they will now take possession of the pictures which are to be hung at the Luxembourg.

When you reach the stage of organizing and hanging the exhibition, don't hesitate to let me know and make free use of me. You know how happy I am to do something for his memory.

Monet to Martial Caillebotte
(Gustave's brother), 22 May 1894

Monet and Sisley

Alfred Sisley commended his children to Monet's care just before his death.

Poor Sisley asked to see me eight days ago, and I saw quite clearly that he was bidding me farewell. Poor old friend, poor children!

Monet to Geffroy
29 January 1899

My dear friend,

I am currently arranging a sale to help Sisley's two children, who have been left penniless, and since their father has bequeathed them very few paintings from his studio, we are to contribute some pictures by his friends and colleagues to the sale of his work, which should raise the funds his poor children need. Naturally I am assured of the co-operation of everyone who took part in our early exhibitions, and I thought that if your mother had been alive she would have been glad to join us in this good deed; if you find you have one of her paintings you can bear to part with, to do so would be a homage to her, which would associate both her and you with an act of kindness. As for us, we shall give the best of what we have, so the sale can successfully raise some money for the Sisley children.

Monet to Julie Manet, daughter of
Berthe Morisot and Eugène Manet
Giverny, 23 March 1899

R enoir painted by Bazille (1867).

Monet and Renoir

As young men Monet and Renoir often worked at their easels side by side. Monet was deeply affected by the illness and death of his friend.

I am at my parents' house, and am nearly always at Monet's ... we don't eat every day. Nonetheless I am happy, because Monet is very good company for painting.

Renoir to Bazille
Louveciennes
summer 1869

Do you want to know the state I am in and how I have been living for the last week? Ask Renoir, who brought us some bread from his home, to keep us from dying of hunger.

Monet to Bazille
Saint-Michel (Bougival)
9 August 1869

Congratulations on the article about the Renoir portrait. Yes, that man is a beautiful and rare painter.

Monet to Geffroy
Giverny, 6 July 1912

You will have guessed that Renoir's death has been a great sorrow to me; he has taken with him a part of my life. These last three days I have thought over and over again about our early years of struggle and hope It is hard to carry on alone, though it certainly won't be for long: every day I feel age gaining on me, though people say otherwise.

Monet to Fénéon
mid-December 1919

Monet and Degas

Degas did not always like or understand Monet's work, which he saw as 'commercial', or as the product of a 'decorative talent'. Still, their friendship survived down the years. When he was almost blind, Degas did not hesitate to travel down to Giverny for Alice Monet's funeral in 1911.

I have just had a letter from the Bernheims asking me to intervene with Degas' brother on their behalf, so they can assist you with the public auction. Even though I don't know Degas' brother, my admiration for Edgar's talent, our friendship as young men and our shared struggle would permit me to write to him on the subject.

Monet to Joseph Durand-Ruel
Giverny, 15 October 1917

Monet and Vincent van Gogh

Van Gogh often referred to Monet's art in his letters. He was keenly interested in the Monet–Rodin exhibition, the catalogue of which was sent to him by his brother Théo.

There are many things to see here In Antwerp, I never even knew what the Impressionists were; now I have seen them, and although I am not yet one of their club, I am a great admirer of some of their paintings ... [notably] a landscape by Claude Monet.

Van Gogh to H.M. Levens
Paris, summer or autumn 1886

At the moment my brother is mounting an exhibition of Claude Monet. I would very much like to see it. Guy de Maupassant went there, among others.

Van Gogh to Emile Bernard
Arles, June 1888

You will do something like Durand-Ruel, who recognized the personality of Claude Monet before the others, and bought his paintings.

Van Gogh to his brother Théo
10 September 1888

Oh, to paint figures as Claude Monet paints landscapes! In spite of everything, that is what remains to be done, before Monet comes to be seen as the only Impressionist.

Van Gogh to Théo
May 1889

Monet and Signac

Written on the occasion of Monet's Venice *exhibition at the Bernheim-Jeune Gallery in 1912, this splendid exchange of letters between Monet and the Post-Impressionist painter Paul Signac reveals their mutual respect.*

Dear Master,
Confronted with your *Venice* paintings, such admirable renderings of subjects I know so well, I felt an emotion as complete and strong as that which I had experienced in about 1879, in the *Vie Moderne* exhibition room, before your paintings of the *Gare Saint-Lazare* and *Rue Montorgueil*. It was this experience that decided me to become a painter.

A painting by Monet always moves me, always teaches me something, and on my days of discouragement and doubt, a certain Monet has been a friend and guide to me.

And these *Venice* pictures, even better, in which everything unites as the expression of your will, in which no detail runs counter to emotion, in which you have achieved the sacrifice of genius that Delacroix always recommended to

us – I admire them as the highest incarnation of your art.

Signac to Monet
31 May 1912

The insulting criticisms of the early days left me cold, and I remain just as indifferent to the present praises of imbeciles, snobs and wheeler-dealers. But the opinion of one or two people, among whom I include yourself, is precious to me I am sorry that your health has deprived me of the joy of talking with you.

Monet to Signac
Giverny, 5 June 1912

Monet and Denis

In the 1920s Monet was linked to the Nabis, and particularly to Bonnard. In this New Year message he shows his interest in Maurice Denis' decorations for the Petit Palais.

Dear Maurice Denis,
This is to encourage you, and to offer you all my sympathy. I was very happy with the photograph of your work and can imagine what it must be like. Unfortunately, I have become thoroughly homebound and hardly ever come to Paris; but the day I do, I shall not fail to go to the Petit Palais.

Monet to Denis
Giverny, 4 January 1926

Monet and Kandinsky

Monet's Haystacks *provided Wassily Kandinsky with a revelation that was to lead him to abstract art.*

I experienced two events that set their seal on my entire life, and moved me in my deepest soul. These were the Impressionist Exhibition in Moscow,* where I saw Monet's *Haystacks*, and a performance of Wagner ... suddenly, for the first time, I *saw* a painting
I dimly understood that the painting lacked an objective ... all of this was confusing to me, and I was incapable of drawing the most elementary conclusions from this experience.

Wassily Kandinsky.

But one thing was quite clear: the undreamt-of power of the palette, which had hitherto been hidden from me. From it the painting received a force and a vividness that were fabulous. But also, unconsciously, the idea that an object is an indispensable element of any painting had been discredited.

Wassily Kandinsky
Rückblicke, 1913

* Winter, 1896–7

Monet and Rodin

The friendship between the painter and the sculptor Auguste Rodin survived well beyond the Monet–Rodin Exhibition of 1889.

My dear Rodin,
I must tell you how overjoyed I am with the beautiful bronze you have sent me. I have put it in my studio so I shall be able to look at it all the time. I came back here filled with wonder at your *Gates [of Hell]* and at everything else I saw at your house.

<div style="text-align: right">

Monet to Rodin
Giverny
25 May 1888

</div>

I have agreed to do an exhibition at Petit's gallery, of my paintings with Rodin's sculptures. It is a huge affair. The show will last three months during the Universal Exhibition, with an eye to the foreign public which will be visiting Paris then.

I therefore need a certain number of pictures, because I want a choice of what I have done in the past mingled with new things. So I am asking for your co-operation. This exhibition may have a certain success and will be a chance for you to make sales.

<div style="text-align: right">

Monet to Paul Durand-Ruel
Fresselines
1 May 1889

</div>

Your letter delighted me, because you know that, bound up as we both are by our pursuit of nature, our friendships suffer. But the same constant feeling of brotherhood, the same love of art, has made us friends for all time, so I am happy to have your letter.

It must be very hard, at a certain age, to lose a friend or find him indifferent; at the very thought of it I also suffer, my dear friend. I have the same unchanging admiration for you as the painter who helped me understand the light, the clouds, the sea and the cathedrals; I loved these things already, but their dawning beauty as revealed by you has touched me very deeply.

My best wishes to you then, my dear friend and companion, as well as to Mirbeau and Geffroy, whom I also love well.

<div style="text-align: right">

Rodin to Monet
Montrozier (Aveyron)
22 September 1897

</div>

I got to the Salon only yesterday ... I have finally seen your *Balzac*. I was sure it would be beautiful, but it surpassed all my expectations; I tell you this in all sincerity.

You can forget the howls of the critics, you have never gone so far before; it is absolutely beautiful and great, it is superb, and I cannot stop thinking about it.

<div style="text-align: right">

Monet to Rodin
Giverny, 30 June 1898

</div>

My dear friend,
You make me very happy with your appreciation of *Balzac*. Thank you. Your opinion is one of those which give me strength; I have had a torrent of abuse, not unlike what you had in the old days, when it was modish to laugh at your innovation of putting air into landscapes

Your triumphant exhibition gives new strength to all artists who are persecuted as I am now. What an effect, one that has never been achieved before

– and what a thing is that cathedral in the mist!

Your old friend.

Rodin to Monet
7 July 1898

You ask me to tell you what I think of Rodin. I wish to tell you of my deep admiration for this man, who is unique in our time, and a great man even among the very greatest.

Monet to the writer Arsène
Alexandre, Giverny
25 April 1900
(quoted in preface to the
'1900 Exhibition Catalogue:
The Work of Rodin', Paris)

My dear Maître,

My best wishes, Monet ... and thank you for joining the committee for *The Thinker* and for your subscription ... dear old friend, it is so good to be together again once in a while.

Your admirer.

Rodin to Monet
30 December 1904

My dear Rodin,

Thank you for your letter and your good wishes, which touched me very much. The next time I come to Paris, I will manage things so I can come and pay you a visit ... and I also want to go and see how *The Thinker* looks at the Panthéon.

Your admirer and friend.

Monet to Rodin
Giverny, 2 January 1905

I wish to record my complete support for your project for a Musée Rodin; I am happy to have this chance to show my admiration for this great artist.

Monet to Judith Cladel
Giverny, 20 December 1911

Monet and Maillol

In 1903, next to the name of Rodin, that of Maillol was foremost in Monet's appreciation of contemporary sculpture.

I deeply regret that Rodin has not been commissioned to do Zola's monument. To whom else can they apply? Well, to a young man with great promise who can give proof of it with just such a project. Maillol immediately springs to mind. He is the only one, apart from Rodin.

Monet to Duret
Giverny, 15 January 1903

Monet and Paul Nadar

This letter, addressed to the son of the celebrated photographer Nadar, who had lent his studio for the First Impressionist Exhibition in 1874, shows Monet's strong preference for 'what is natural'.

Dear Monsieur Nadar,

I hear you are to do a portrait of my step-son J.-P. Hoschedé and his fiancée, and that you are enquiring about whether to use draperies. Personally, I would like you to photograph them as simply as possible, just as they are.

Note that I don't say as *well* as possible, since I know from experience that you get the best from your models. All I wish to do is remind you of my predilection for completely simple portraits, without props.

Thank you for the constancy of your friendship.

Monet to Paul Nadar
Giverny, 10 December 1903

Fervent and discerning critics

'One thing I am glad about, is that I live in the same era as Monet.' This remark, attributed to Mallarmé, might have been made by any one of Monet's other writer friends. From the painter's first difficult beginnings, writers were important in his life; after his success (to which they contributed) they remained loyal to him in times of grief. 'I need so badly to feel I have friends', Monet once wrote to Geffroy (26 December 1902).

Monet and Zola

Zola noticed Monet's work the very first time it appeared in the Salon; critic and painter soon became friends.

He has it in him to be a seascape painter of the highest order. But he understands the genre in his own way, and here again you note his deep love for immediate realities. In his seascapes there is always the end of a jetty, a corner of some quayside, something that indicates a date and a place. He seems to have a weakness for steamships. He loves the water like a mistress, he knows every piece in the hull of a vessel, he could put a name to the least line in her rigging.

I should probably admire these paintings very little, if Claude Monet were not a true painter. All I want to point out is the sympathy which draws him to modern subjects. But while I approve of his way of seeking out subject matter in the milieu he inhabits, I congratulate him even more for knowing how to paint, for having an exact, honest eye, for belonging to the great school of naturalists. What distinguishes his talent is his incredible ease of execution, his supple intelligence, his quick and lively understanding of any and every subject.

I have no fears for him. He will conquer the crowds whenever he chooses. Those who smile at the intentional harshness of his seascapes this year, should remember his picture of his wife in a green dress in 1866. When a man can paint a fabric as beautifully as that, he knows his craft inside out, he has assimilated all the new methods, and he can do as he pleases. I expect nothing

P hotograph of Emile Zola.

more from him save what is good, exact and true.

Emile Zola
'Mon Salon, IV, Les Actualistes'
L'Evénement illustré, 24 May 1868

My dear Zola,
You have kindly sent me a copy of *L'Oeuvre*, and I thank you for it. I have always enjoyed reading your books, and this one is doubly interesting to me because it raises those questions about art for which we have been fighting so long. I have just read it, and I confess it has left me troubled and uneasy.

You have taken special care that not one of your characters should resemble one of us, but in spite of that I fear that our enemies in the press and the public will use the names of Manet and more or less all our friends as examples of failure, which I cannot believe is what you intend.

Excuse me for telling you this. It is not meant as a criticism. I have read *L'Oeuvre* with great pleasure, and every page raised some memory. Moreover you know I am a fanatical admirer of your talent. All the same I have been in the thick of it for a long time, and my experience leads me to worry that at the crucial moment our enemies will use your book to bludgeon us.

Monet to Zola
Giverny, 5 April 1886

My dear Zola,
Bravo once again and with all my heart, for your superb gallantry and courage.*
Your old friend.

Monet to Zola
Giverny, 14 January 1898

* Monet wrote this the day after Zola's celebrated article, 'J'accuse', *L'Aurore*, 13 January 1898

Monet and Duret

The critic Duret, who had spent time in Japan and who was a connoisseur of Japanese art, was one of the first buyers of Impressionist paintings. In 1878 he wrote a book on them, and in 1880 he supplied the preface to the catalogue of Monet's first private exhibition.

The first thought that came to mind in the presence of such complete 'series' as *Haystacks* or *Cathedrals* was that Monet had somehow simplified his work by repeating the same subject over and over, and that he must have reached a point after the first two or three attempts where he could paint without difficulty. So it was thought that in executing his 'series' he had set out to make his task easier, and to produce the maximum of pictures with the minimum of effort. The truth is exactly the opposite. Since embarking on his 'series', he has actually produced fewer canvases than before. It turns out that painting different scenes, once only, was easier than producing many versions of the same scene in different guises. To catch on canvas, with precision, the various aspects of a scene, is an operation of great delicacy requiring exceptional vision. To paint like this one must grapple with real abstractions. One must contrive to separate the elusive theme from its unchanging background, and to do so in one fell swoop; for the different effects to be grasped can, in their ephemerality, overlap one another, becoming confused if the eye does not arrest them of itself.

Monet bore up in his times of trial and sorrow with great force of character. Then, when success came to him, he was unaffected by it. He did not seek to obtain official advantages, as so many

other artists are inclined to do, and in particular he refused to accept the Legion of Honour. He was ever a trusty friend to his Impressionist colleagues. He was the most able defender of Degas, Pissarro, Cézanne, Renoir and Sisley; and he never ceased to express his deep admiration for Manet, and to acknowledge everything he owed him.

He was perpetually intrigued by the spectacle of water. In the many different places where he worked, he introduced water as an integral part of his paintings. At Giverny, he painted the water he found there in many different ways. The water-lilies and the reflections of his garden pool provided him with two of his most recent series; and now at the close of his career he returns to this subject in a singular manner. He approaches it as a decorative theme.

Théodore Duret
Histoire des Peintres Impressionistes
Paris, 1906, reprinted 1919

Guy de Maupassant.

Monet and Maupassant

With their shared talent for 'describing' landscape, Monet and Maupassant met several times at Etretat, notably in autumn 1885.

Last year I several times accompanied Claude Monet on his quest for impressions. At such times he was no longer a painter but a hunter. He went about followed by a gaggle of children who carried canvases, five or six at a time, representing the same subject at different times of day and with different effects. He took the pictures up and abandoned them turn and turn about, according to the changing sky. And the painter, confronting his subject, waited and watched for the sun and the shadows, caught with a few brushstrokes a ray of sunshine or a cloud, and, scorning the false and the conventional, rapidly spread them on his canvas. I have seen him capture a glistening shaft of light on a white cliff, and fix it in a rush of yellow tones which made the effect of its elusive dazzlement strangely blinding and unsettling. Another time he appeared to seize a shower of rain on the sea in both hands and throw it against his canvas. And indeed it *was* the rain that he had painted in this way, nothing but rain veiling the waves, rocks and sky which were barely discernible through the downpour.

Guy de Maupassant
'La Vie d'un Paysagiste
(Etretat, Septembre)'
Gil Blas, 28 September 1886

Monet and Mallarmé

Monet and Stéphane Mallarmé might have left a collaborative work of art, had Monet not declined to illustrate a text by his friend. In compensation, the painter gave the writer a painting, on Sunday 13 July 1890, at Giverny. Berthe Morisot was frequently the go-between for the two men.

My dear friend,
Thank you for your kind letter. I am very happy that you like my paintings,* praise from such an artist as yourself gives me great joy.

Monet to Mallarmé
19 June 1888

* *Antibes Seascapes*, which were exhibited by Théo van Gogh at the Boussod–Valadon Gallery.

One may not disturb a man who is rapt in the kind of joy that is given to me by the contemplation of your painting, dear Monet. I drown in its brightness and consider that my spiritual health stems from the fact that I can always keep it more or less in sight, according to the hours I keep. I scarcely went to bed the first night, for looking at it; and in the carriage Mme Manet [Berthe Morisot] was ashamed that I only feared the lurchings of the horse on my painting's account You, sad? And you the only being that no discouragement should ever taint!

Mallarmé to Monet
Paris, 21 July 1890

*Monsieur Monet, que l'hiver ni
L'été sa vision ne leurre
Habite, en peignant, Giverny,
Sis auprès de Vernon dans l'Eure.*

(Monsieur Monet, who misses nothing
Either of winter, or of summer
Lives and paints at Giverny
Near Vernon, in the Eure.)

Mallarmé, on the envelope
of a letter to Monet
summer 1890

Monet and Proust

Along with the paintings of Monet, Proust mentions Giverny in his work. (Whether he actually saw the house, or only imagined it, is not certain.)

What charming hours were those. The sun shone full upon the loveliest painting by Claude Monet that I know of: *Tulip Fields near Haarlem*.* Before his marriage the prince had coveted this at an auction, 'but', he said, 'to my fury the thing was snatched from under my nose by an American lady whose name I immediately consigned to the fires of hell. A few years later I married that American lady and gained possession of the painting!'

Marcel Proust, under his pseudonym
'Horatio', 'Le Salon de la Princesse
Edmond de Polignac, Musique
d'aujourdhui, échos d'autrefois'
Le Figaro, 6 September 1903

* The version of *Tulip Fields* bequeathed to the Louvre by Winnaretta Singer, Princess Edmond de Polignac; it is now at the Musée d'Orsay, Paris.

Monet and Mirbeau

Octave Mirbeau was one of the most ardent defenders of Monet's art. Monet read what he wrote and told Geffroy in 1890: 'Mirbeau has become a master gardener. Gardening, and the Belgian Maeterlinck, are all he ever thinks about.'

We had a very gay dinner; then we had to look at the paintings in the lamplight.

Octave Mirbeau.

First outpourings of enthusiasm from Mirbeau. We had to look at them again in the daylight, at which Mirbeau really went over the top ... this evening the talk about art and literature kept me up after my usual bed-time Naturally I am happy when people like my pictures, but Mirbeau is really such a fanatic.

Monet to Alice Hoschedé
Belle-Ile, 4 November 1886

I went to spend a week with Monet on his island of Belle-Ile. And I await him on my island of Noirmoutier. He has done some very great paintings, revealing a new facet of his talent. Tremendous, formidable Monet ... he is a man of heroic courage, and if anyone deserves to succeed as well as you, it is he.

Mirbeau to Rodin
November 1886

Claude Monet understands that in order to achieve a more or less exact and emotive interpretation of nature, what should be painted in a landscape is not just its general lineaments, nor its partial details, nor the lie of its land and its greenery, but the moment you choose to paint it, when its character emerges; such is immediacy. Monet observed that on an average day, a given effect hardly lasts thirty minutes. Hence he had to tell the story of those thirty minutes, which is to say that in a given piece of nature, those minutes express both harmony in light, and harmony in concordant movements. This observation applies to figures, too (because these are really no more than a collection of shadows, lights, reflections and all things changing and shifting), just as it does to landscapes. The *motif*, and the instant of the *motif*, having been selected, Monet puts forth his first impression on the surface of the canvas.

Octave Mirbeau
Preface for the catalogue of the
Monet–Rodin exhibition, Paris
Georges Petit Gallery, 1889

Monet and Rolland

Romain Rolland was an assiduous visitor to museums and galleries. Here he writes of Durand-Ruel's exhibition of Monet's Water-lilies *in 1909.*

I admire you most of all, among today's French artists. Art such as yours is the glory of a nation and of an era. When I am a little digusted by the mediocrity of modern music and literature, I need only turn to painting, where works like your *Water-lilies* are blossoming, to reconcile myself with the art of our time, and to believe that it stands

JOURNAL DE **VU** LA SEMAINE

CLEMENCEAU ET CLAUDE MONET SUR LA SCÈNE

CE QUE L'ON A VU AU SALON DE L'AUTOMOBILE

Scene from Sacha Guitry's 1918 play *Histoire de France* in which Monet (played by Guitry himself) and Clemenceau (Jean Périer) meet at Giverny.

comparison with the greatest that has gone before. I have admired your work for over twenty years, from the time when I was still at the lycée [college] and saw an exhibition of yours (the Belle-Ile paintings of rocks beaten by the sea).

Rolland to Monet
14 June 1909

Monet and Guitry

The playwright Sacha Guitry, who was a frequent visitor to Giverny and often received Monet at his house at Yainville, never failed to send the painter seats for the dress rehearsals and first nights of his plays.

I have just received two tickets for Sacha's dress rehearsal.* I am coming up tomorrow with my step-daughter and we hope to see you at the theatre.

Monet to G. or J. Bernheim-Jeune
Giverny, 2 October 1916

* *Faisons un rêve*, at the Bouffes-Parisiens Theatre, 3 October 1916.

My dear Sacha,
I am most touched by your letter and your good wishes. I shall never forget those happy times at your house, with our dear friend Mirbeau.

Monet to Guitry
Giverny, 5 January 1923

Monet and Geffroy

Monet first met Geffroy at Belle-Ile in 1886. After more than thirty years spent analysing his friend's artistic development, the former art critic of La Justice *published a book about him.*

Well, my dear Geffroy, you were supposed to let me know when you were coming here, and already a month has passed. Come on, bestir yourself a little and name a day, any day, as long as it is soon I have received your article on my exhibition. Many thanks. You are always the one who says best whatever there is to say, and it is always a pleasure for me to be praised by you
Your old friend.

Monet to Geffroy
Giverny, 1 June 1909

In fact, his work resembles nothing else in the history of art. If he had continued with his figurative studies, he could have produced an evocation of the modern world, of people and of theatre. But he left all that to pursue an ever more complex, magical and evocative form

of representation, of aspects of nature as revealed by light. His work is a revelation and a poem, which unveils a universe that nobody before him has ever perceived.

Gustave Geffroy
Claude Monet, sa vie, son oeuvre
1922 (Introduction)

My dear friend,
I had just written you a letter when your book arrived, with its kind dedication.* I need not tell you how touched I am, all modesty apart, by the good things you say about my work and myself For all that you have written so well of my life and labours (I have naturally left aside everything which is documentation, despite the interest it may have for others), I thank you from the bottom of my heart ... thank you again for all the beautiful things in this book.

Your old friend.

Monet to Geffroy
Giverny, 25 June 1922

* Gustave Geffroy, *Claude Monet, sa vie, son oeuvre*, 1922

Monet and Clemenceau

When he was comforting Monet over his cataract problems, the politician-turned-art-critic remembered he had once been a doctor. Monet appreciated Clemenceau's affection during his last years.

Dear friend,
I thought I had discerned that the man in you was worthy of the artist ... but now, without my permission, you bombard me with this monstrous lump of light.* I am still groggy and I don't know what more to say. You cut out chunks of the sky and hurl them at

people's heads. Nothing would be more idiotic than to thank you for this. One cannot thank a sunbeam.

I salute you with all my heart.

Clemenceau to Monet
Paris, 23 December 1899

* A painting done on the Creuse and presented by Monet to Clemenceau: *The Bloc.*

My dear Clemenceau,
I sent you a telegram this morning to express my joy, but I still want you to know how grateful I am for what you have just done for Manet.*

I understood the other day that you would do what I had asked of you, and I thank you with all my heart.

Monet to Clemenceau
Giverny, 8 February 1907

* Thanks to Clemenceau's intervention, the *Olympia* had just been transferred from the Musée du Luxembourg to the Louvre.

And now my old friend Clemenceau is in power. What a burden; may he do good work despite all the traps that will be set for him! What magnificent energy he has, nonetheless!

Monet to G. or J. Bernheim-Jeune
Giverny, 26 November 1917

My dear and great friend,
I am on the brink of completing two decorative panels, and would ask you if you will offer them to the State. It is a small gesture, but the only way I have of participating in France's victory.

I admire and salute you with all my heart.

Monet to Clemenceau
12 November 1918

Clemenceau is faithful as ever, and comes often to see me. It seems to do him good to come and talk things over, and he cheers me up, too. What a man!

Monet to Geffroy
Giverny, 8 December 1919

Monet and England

M. Monet's constant study of natural effects has produced in his mind a complete divergence from those ideas about landscape colour which are born and bred in studios in great cities. The city painter fancies that nature is grey or brown, with a little dull green on grass, or permissible pale blue in the sky towards the top of the picture.

M. Monet has seen the real colouring of nature – seas of sapphire and emerald, or dark purple and violet far away, cliffs of brilliant white or stained with reds incredible to the citizen critic, and confused medleys of the richest colours in weedy pools upon the sands. He has seen the Atlantic waves beat wildly on the purple rocks of Brittany; he has studied the Mediterranean, with its pale, pure blues and greens, dark by comparison with the sun-baked fortifications of Antibes and the aërial radiance of the distant maritime Alps. For variety of observation, joined to complete singleness of purpose in each separate work, no French landscape-painter is comparable to Claude Monet. The utmost dreariness of a frozen river and a snowed-up little town in Normandy, the summer glory of the south, the burning autumnal foliage by some quiet trout-stream in contrast with the persistent green of its grassy bank, are all equally interesting to this open-minded observer; and each separate phase of nature that he represents occupies him exclusively at the time, so that there is never any confusion in his mind between one motive and another. Yet for many years Monet has been a most unpopular artist, and his unpopularity has been due both to his merits and his defects. First, he sees and imitates natural colour (including even the bluish or violet shadows in landscape), colour that always puzzles and amazes the unobservant; and he tries to raise the key of his tonality as high as he can towards the exalted pitch of natural light – two endeavours that are sure to make pictures look glaring, especially whilst the paint is fresh. In colour and light Claude Monet does not paint what other people expect or want to see, but tries for what he has himself seen in nature. Next, he has the purest possible landscape instinct, not seeking much or often for adventitious human interest, as the old masters always did, and as prudent moderns have done generally. A lonely place is interesting for him if it has natural beauty or character – or even an effect may make it interesting. Now, as to imperfections, although M. Monet is said by his friends to be a good draughtsman when he chooses, he puts very little drawing into his painting; he is not half so sensitive to the beauty of form which exists in natural landscape as he is to its glory of colour and brilliance of light, and for those who love the delicate beauty of form, this inattention to it is vexatious. The desire for broad truth of colour and effect has caused M. Monet to pass over natural detail, which has an infinite charm for many who love nature as sincerely as he does himself, but in a different way.

Philip Hamerton
'The Present State of the Fine Arts in France: Impressionism'
Portfolio, February 1891

Monet at his easel

Monet was always an enemy of theories; one of his favourite comments was that 'a painter has better things to do than write'. He rarely revealed his ideas about art. Nevertheless, his letters yield interesting sidelights on his way of working and his approach to subject matter. They show how far painting was for him a permanent preoccupation, and even (in his own words) an obsession.

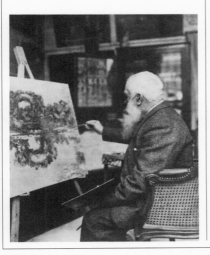

Drawing – 'with the brush and with colour'

Here Monet defines himself as a painter.

Dear Sir,
I have no idea how to answer you ... since I only draw with the brush and with colour, and have always refused (even when asked by my closest friends) to attempt a style of work about which I know nothing. I am very sorry to have to refuse your request I do still possess one or two rare sketches I did in my youth, but they are neither very interesting, nor worthy to be reproduced.

> Monet to an unknown correspondent
> Giverny, 5 April 1914

Painting in the presence of nature

I had two studies, of apple trees loaded with fruit, which I had to abandon. When I arrived at the place where I was to work, there were *no more apples* – they had all been picked. Which means two more canvases wasted ... this is discouraging.

How I envy people who can paint from memory.

> Monet to Duret
> Vétheuil, 3 October 1880

No, I am not a great painter, nor a great poet I only know that I do what I can to express what I feel in the presence of nature.

> Monet to Geffroy
> Giverny, 7 June 1912

I have always had a horror of theories ... my only merit is that I have painted directly from nature, seeking to convey my impressions of her most elusive effects: and I am aghast at being the

cause of a name given to a group of artists of whom the majority were anything but Impressionists.

<div align="right">Monet to Evan Charteris
Giverny, 21 June 1926</div>

'The sea, which is very much my element'

This confidence dates from Monet's stay in Bordighera, which began on 3 March 1884. All his life and from his earliest beginnings, Monet went out of his way to paint the sea.

You know my passion for the sea, and this particular one is so beautiful. Trained as I am, and constantly observing it, I am sure I would manage to do some excellent things if I could live here for a few more months. I feel I understand the sea better every day, the bitch, and it is certain that the way she is here that name is appropriate, for she is very terrible; she has one of those tones of dull blue-green

In short, I adore the sea, but I know that to do her justice you have to view her every day, at all hours, and from the same point of vantage, so as to learn how she lives.

<div align="right">Monet to Alice Hoschedé
Belle-Ile, 30 October 1886</div>

And now come his first seascapes: the Channel, Le Havre, Trouville, Honfleur, the sea caught in its most mysterious rhythms, captured in its mistiest distance, with solitudes lulled by the perpetual lamentation of waves; its swarms of boats, its sandy beaches, cliffs, and rocks; the sea, one of the great passions of Monet's life, through which, magnificent poet that he is, he conveys in physical terms his heartrending awareness of the infinite.

<div align="right">Octave Mirbeau
Preface to the catalogue for the
Monet–Rodin exhibition, 1889</div>

On the 'series' paintings

*From the first, the method for Monet's series (*Haystacks, Poplars *and* Cathedrals*) was systematized to its logical limit; the canvases were completed in his studio, and often with a view to their effect as a group. As a result Monet was accused of working from photographs.*

No, I am not in London save in my thoughts, since I am working exclusively at painting

For the work I am doing, I need to have them all in view, and to tell you the truth, not one has actually been completed. I inch them forward all together, or at least several at a time.

<div align="right">Monet to Durand-Ruel
Giverny, 23 March 1903</div>

Like you, I am sorry not to be able to exhibit the *Water-lily* series this year ... it is not because I want to show a lot of them at once that I am delaying the exhibition – absolutely not – but because I really have too few satisfactory ones to justify alarming the public ... moreover, it would be very bad to show the few I have in the series so far, since the desired effect can only be produced by displaying them all together. In addition to this, I need to have the completed things here where I can see them, so I can compare them with the ones I plan to do.

<div align="right">Monet to Durand-Ruel
Giverny, 27 April 1907</div>

Harrison said all kinds of spiteful things and criticized everything. He said 'Monet is covering a mass of canvases in his studio; just recently he asked me to send him photographs of the bridges in London and of Parliament so he could finish his views of the Thames'.

Durand-Ruel to Monet
Paris, 11 February 1905

Dear Monsieur Durand,
You are quite wrong to worry about the things you tell me, which attest to nothing more than ill-will and jealousy and which leave me absolutely cold. I know Mr Harrison. Sargent asked him to take a small photo of Parliament for me, which I was never able to use. But that means very little, and whether my *Cathedrals*, my *Londons* and my other pictures are done from life or not is my affair and anyway is of no importance whatever. I know plenty of painters who work from life and produce nothing but hideous things.

Monet to Durand-Ruel
Giverny, 12 February 1905

'My work belongs to the public'

Monet's pictures are the best guide to the artist. Monet himself was always very reticent: 'I confine myself to my brushes', he wrote succinctly to Louis Vauxcelles (28 September 1900).

I am old and I live a retired life. I loathe self-advertisement, interviews and the like. People can talk about and discuss my work, but my life is nobody's business but mine.

Monet to André Arnyvelde
Giverny, 19 November 1913

I was hoping you would completely give up your idea, and that made me happy

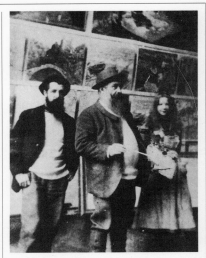

M onet often received friends and visitors in his studio (*c.* 1900).

since I hardly like being made conspicuous, and (without any false modesty) do not believe I deserve it at all. As a painter I have done what I could, and that is quite enough for me. I don't like to be compared to the great masters of the past, and it is quite sufficient that my painting is open to critical appraisal. You know my fondness for M. Fénéon. I will be delighted to receive him and talk with him, but I draw the line at dictating my memoirs.

Monet to G. or J. Bernheim-Jeune
Giverny, 24 November 1918

My works belong to the public, and the public can say what it likes about them. I have done my best; but I refuse to be bothered with questions, and see no reason why I should.

Monet to Geffroy
Giverny, 20 January 1920

'Painting is such torture!'

I am fairly happy with the results of my stay here, even though the studies I have done are far from what I had hoped. It is appallingly difficult. I think there's hardly anybody left like me, hardly anyone who won't stand for half measures. Well, my friend, I will struggle and scrape and start anew, and it seems to me when I look out at nature that I am going to do everything, record everything, and to hell with all else when work's in progress

All this goes to show one must think of painting and of nothing else. Only by observation and thought can one find the way.

Monet to Bazille
Honfleur, 15 July 1864

For a month I've been unable to do anything decent. I've scraped off and torn up just about all my work. I am very disgusted with myself; a superb summer wasted. Painting is such torture! And I am no good at all.

Monet to Caillebotte
Giverny, 4 September 1887

When you ask Monet about his art, you know straightaway that he has never been happy with his work, as compared to his dream of what it could be. He has glimpsed the limitless poetry of light and atmosphere, and he believes himself incapable of capturing it. He is quite wrong.

Gustave Geffroy
Claude Monet, sa vie, son oeuvre
1922 (Preface)

'All my time is given to painting' ... right up to the end

Working at his easel in the garden at Giverny, Monet tried to forget his personal grief, war, and the cataracts that were increasingly affecting his sight.

I am back at work. It's still the best way to avoid thinking too much of the current miseries, although I am a little ashamed to be thinking of infinitesimal researches in form and colour when so many people are suffering and dying for our sakes.

Monet to Geffroy
Giverny, 1 December 1914

I am a slave to my work, forever in pursuit of the impossible ... I have little time left to live and I must give all of it to painting, in the hope that I will finally achieve something fine, which if it is possible will also satisfy me.

Monet to G. Bernheim-Jeune
Giverny, 3 August 1918

I am caught up in my work with no thought for anything else, so happy am I to see colours again. It is truly a resurrection.

Monet to G. Bernheim-Jeune
Giverny, 6 October 1925

My dear good friend,
I was so much better that I thought of getting my brushes and palette ready for work again, but relapses and new pain kept me from doing so. I am still in high hopes and am busy with major alterations to my studio and changes for the better in the garden. All this to show you that my courage is high and I am in control Also, if I do not gain the strength to do my panels as I would like to, I have decided to give them as they are, or at least some of them.

Yours more than ever.

Monet to Clemenceau
Giverny, 18 September 1926

The 'painter's garden' at Giverny

From the beginning, and throughout his years at Argenteuil and Vétheuil, Monet was interested in gardens and represented them in his paintings. When he moved to Giverny in 1883, he became an 'artist-gardener', indulging his passion for flowers and creating an extraordinary water garden. The garden at Giverny is today synonymous with Monet's life and work.

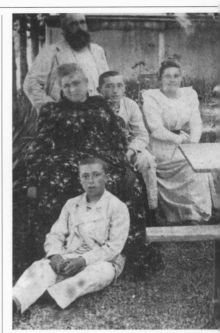

Clemenceau, Monet and Lily Butler on the Japanese bridge, 1921.

'And are there still flowers in the garden?'

Even when he travelled, Monet's thoughts were seldom far from Giverny. He questioned Alice constantly about the state of the garden, worried about the effect of temperature on his flowers and gave instructions for the greenhouse.

And are there still flowers in the garden? I hope there will still be chysanthemums when I get home. If it freezes, make beautiful bouquets of them.

> Monet to Alice Hoschedé
> Etretat, 24 November 1885

Thank you for taking care of my beloved flowers; you are a good gardener. There's no pressing need to lift

The Monet-Hoschedé family gathered at Giverny. Monet stands at left, behind Alice.

the gladioli, but when you do I recommend hardy perennials, like anemones and my pretty clematis.

Monet to Alice Hoschedé
Belle-Ile, 2 November 1886

I have found some wall-flowers at last. Several baskets of them are on their way to Vernon. There are some very good gardeners here In one of the baskets will be other plants, some perennials, passiflora for the greenhouse, some very pretty yellow flowers and two curious little nasturtiums.

Monet to Alice Monet
Rouen, 7 March 1893

What you say about my poor little roses is very worrying, and I fear plenty of other disasters. Did anyone think at least to cover the Japanese peonies? It would have been plain murder not to do so. I'm dying to see the greenhouse and I hope it will still be beautiful. What bliss it will be to come home again!

Monet to Alice Monet
Sandviken, 17 March 1895

'I hate to leave Giverny, especially now that I am arranging the house and garden as I want them'

Monet made this remark to Mallarmé a few months after buying his new property.

I remain as domestic as ever, delighting in the lovely things around me.

Monet to Geffroy
Giverny, 23 August 1900

Dear friends,
I would be a liar if I told you I am not happy to be back with my family, and to see my flowers again.

Monet to Sacha Guitry
and Charlotte Lysès
Giverny, 25 August 1913

Thank you for your offer to remove my pictures, but in spite of what people are saying, and although the Musée de Rouen has been evacuated, I refuse to believe I shall ever be forced to leave Giverny. As I have already written, I prefer to die here surrounded by everything I have made.

Monet to G. Bernheim-Jeune
Giverny, 21 June 1918

What is happening to me, you have readily guessed. I am working, and not without difficulty, because my sight is going a little more each day. I am also

very busy in my garden, which is a joy to me, and in this lovely weather we have been having I am exultant, revelling in nature. With all this, there is no time to be bored.

Monet to G. Bernheim-Jeune
Giverny, 23 February 1920

Gardening and flowers: a passion shared with other initiates

Monet's old friends were always being invited to admire his garden. Mallarmé sent him affectionate poems, other friends exchanged their paintings with him, and still others exchanged flowers.

The countryside is so lovely, I wanted to write and ask you to come and see the garden, which is beautiful at present: worth the trip, and in fifteen or so days it will be over.

Monet to Geffroy
Giverny, 25 May 1900

I am still awaiting your promised visit. This is the moment you will see a splendid garden. But you must hurry ... any later and there will be no flowers. Work it out with Geffroy and write to me. I am counting on you. Also I have a pile of new pictures. With my best wishes. Bully Geffroy a bit and come down.

Monet to Clemenceau
Giverny, 29 May 1900

I will arrange to have the roses I ordered sent as quickly as possible, and will go to Yainville with the plants I plan to give you ... and put the whole lot down in front of me.

Monet to Charlotte Lysès
and Sacha Guitry
Giverny, 31 March 1914

I have sent to you, care of the Sables railway station, a basket of aubretias, the violet border you like. I think they

should come on well in your soil, if planted in the sun I also want to send you some Pennsylvania roses, which grow very well by the sea.

Monet to Clemenceau
Giverny, 29 September 1923

I would be very happy to see you. I will let Monet know and we can have a charming day together. We'll talk paintings and flowers and boats, three things we all adore!

Mirbeau to Caillebotte
(undated)

'An interior which is very much to our taste ...'

The house at Giverny thus described by Monet (to Alice, from Norway, 31 January 1895) was inseparable from the garden. Supported by Alice, an accomplished housekeeper, Monet shared his special, almost English way of life with his guests. An interest in cooking and the preparation of delicious food served, among other things, to unite his circle of friends.

My dear Mallarmé,
Would you be kind enough to send me your recipe for chanterelles? There are lots about at the moment, and in my greediness I remembered your promise.

Monet to Mallarmé
Giverny, 21 July 1890

This house, though modest, is nonetheless sumptuous on account of its interior and the garden, or rather, the gardens that surround it. The man who has conceived and established this small, familiar, magnificent world of his own is not only a great artist in the creation of his paintings, but also in the environment he has made for himself, for his own delight. This house and

M enu for the wedding lunch of Germaine Hoschedé at Giverny, 12 November 1902.

garden are likewise a work of art, and Monet has invested his life in the creating and perfecting of it.

Gustave Geffroy
Claude Monet, sa vie, son oeuvre, 1922

Japan in a Normandy garden

The orchard, or clos normand, *which lay beneath the windows of the house at Giverny, gradually yielded to the flower garden created by Monet, who filled it with flower species and flowering shrubs from Japan. Monet's borrowings from Japanese gardens are even more evident*

in his water garden, with its bridge, bamboos and water-lilies.

Thank you for thinking of me for the Hokusai flowers [Japanese prints]. You say nothing of the poppies, and that is what is most important, for I already have the irises, the chrysanthemums, the peonies and the volubilis.

> Monet to Maurice Joyant
> Giverny, 8 February 1896

Here we have masses of flowers; the plums, Japanese apricots and narcissi are blossoming ... our weeping willows are completely green.

> Monet to Jean-Pierre Hoschedé
> Giverny, 8 February 1916

I was flattered by your two letters, having the deepest admiration for Japanese art and great sympathy for the Japanese I received your lovely prints with profound pleasure.

> Monet to Shintaro Yamashita
> Giverny, 19 February 1920

'A place of tints and hues, more than of blossoms'

The world Monet created was an inspiration for many writers (Duret, Mirbeau, Proust, Geffroy, Clemenceau and Louis Aragon, among others), who grasped the originality of the 'painter's garden'.

Personally, one may say that the Giverny work is the most triumphant exposition of the methods of Impressionism. If the series known as 'Les Cathédrales' be added, one may safely challenge the most critical. It is natural that Giverny should inspire the finest harvest, for, after years of experimental residence, it is here that Monet finally settled in 1883. The dominant note in the

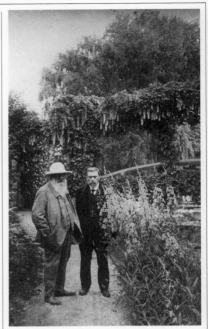

Monet and Geffroy in front of the Japanese bridge, photographed by Sacha Guitry *c.* 1920.

Giverny paintings is one of joy in the beauty of life and nature. They are the works of an inspired genius, who never forgets that Beauty is the mission of Art.

Monet is seen in his most genial moods when, with cigar for company, he strolls through his 'propriété' at Giverny, discussing the grafting of plants and other agricultural mysteries with his numerous blue-bloused and sabotted gardeners

After painting, Monet's chief recreation is gardening. In his domain at Giverny, and in his Japanese water-garden across the road and railway (which to his lasting sorrow cuts his little world in twain), each season of the

year brings its appointed and distinguishing colour scheme. Nowhere else can be found such a prodigal display of rare and marvellously beautiful colour effects, arranged from flowering plants gathered together without regard to expense from every quarter of the globe.

In the neighbouring fields are hundreds of poplars standing in long regimental lines. These trees, which inspired 'Les Peupliers,' were bought by Monet to avoid the wholesale destruction which threatened every tree in the Seine valley a few years ago. The building authorities of the Paris Exhibition required materials for palisading, and thousands of trees were ruthlessly felled to make a cosmopolitan holiday.

In the peace of Giverny we leave the great painter. He is one of the few original members of the Impressionist group who has lived to see the almost complete reversal of the hostile judgment passed upon his canvases by an ill-educated public. Now he is able to enjoy not only the satisfaction of having his principles acknowledged, but also the receipt of the material fruits of a world-wide renown. Not often do pioneers succeed so thoroughly.

Wynford Dewhurst
Impressionist Painting, 1904

Giverny reborn – in 1980

Monet's property was bequeathed by his second son Michel to the Académie des Beaux-Arts. A major programme of restoration work has since been carried out on the house and garden.

It is essential to make the pilgrimage to the flowered sanctuary of Giverny, the better to understand the master, to grasp the sources of his inspiration, and to imagine him still living among us.

Gérald van der Kemp
Preface to Claire Joyes
Claude Monet: Life at Giverny, 1985

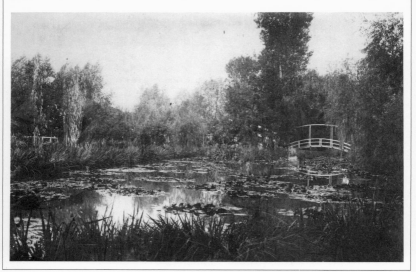

The Orangerie: Monet's testament

Monet died in 1926, before he knew the fate of the Grandes Décorations *he had offered to the French State. Reservations were expressed by some, who saw in the work the end of Impressionism. But most of the artists and thinkers of the century felt deep admiration for it; some have even detected a cosmic, sacred dimension in the 'chapel' of the Orangerie, which was conceived according to the painter's wishes and inaugurated on 17 May 1927.*

8 July 1927. At the Orangerie, in two large, oval rooms, the *Water-lilies* of Claude Monet. Mirrors of water in which the water-lilies flower at all hours of the day, morning, afternoon, evening and night. Claude Monet, at the end of his long life, after studying everything that the different motifs afforded by nature could give him in answer to the question of light's relation to ensembles of colour, concluded by addressing himself to the element that is in itself the most docile and penetrable – water, the epitome of transparency, iridescence and reflection. Thanks to water, he has made himself the indirect painter of what we do not see. He concentrates on the almost invisible, spiritual surface that divides light from its own reflection. The blue of the sky

imprisoned in liquid blue. The only evidence of a surface is the flowers, their whorls of leaves and petals, vegetable emanations of the deep, bubbles, opening eggs. The canvases are glued to the wall in long concave bands that envelop the spectator, who views them both frontally and laterally. The light is beaten into blue, through the chemistry of water. Claude Monet feels the same passion for colour as those who made the stained glass for our cathedrals. Colour rises from the depths of the water in clouds and whirlpools.

Paul Claudel
Journal, 1904–32
8 July 1927

So much has Monet been attracted by the analysis of the laws of light that he has made light the real subject of all his pictures, and to show clearly his intention he has treated one and the same site in a series of pictures painted from nature at all hours of the day. This is the principle whose results are the great divisions of his work, which might be called 'Investigation of the variations of sunlight'. The most famous of these series are the 'Hay-ricks', the 'Poplars', the 'Cliffs of Etretat', the 'Golfe Juan', the 'Coins de Rivière', the 'Cathedrals', the 'Water-lilies', and finally the 'Thames' series which Monet is at present engaged upon. They are like great poems, and the splendour of the chosen theme, the orchestration of the shivers of brightness, the symphonic *parti-pris* of the colours, make their realism, the minute contemplation of reality, approach idealism and lyric dreaming

His recent series of 'Water-lilies' expressed all the melancholic and fresh charm of quiet pools, of sweet stretches of water blocked by rushes and calyxes. He has painted underwoods in the autumn, where the most subtle shades of bronze and gold are at play, chrysanthemums, pheasants, roofs at twilight, dazzling sun-flowers, gardens, tulip-fields in Holland, bouquets, effects of snow and hoar frost of exquisite softness, and sailing boats passing in the sun

Monet excels also in suggesting the *drawing of light*, if I may venture to use this expression. He makes us understand the movement of the vibrations of heat, the movement of the luminous waves; he also understands how to paint the sensation of strong wind. 'Before one of Monet's pictures,' said Mme. Morisot, 'I always know which way to incline my umbrella.' Monet is also an incomparable painter of water. Pond, river, or sea – he knows how to differentiate their colouring, their consistency, and their currents, and he transfixes a moment of their fleeting life. He is intuitive to an exceptional degree in the intimate composition of matter, water, earth, stone or air, and this intuition serves him in place of intellectuality in his art. He is a painter *par excellence*, a man born for painting, and this power of penetrating the secrets of matter and of light helps him to attain a kind of grand, unconsciously lyrical poetry. He transposes the immediate truth of our vision and elevates it to decorative grandeur. If Manet is the realist-romanticist of Impressionism, if Degas is its psychologist, Claude Monet is its lyrical pantheist.

His work is immense. He produces with astonishing rapidity, and he has yet another characteristic of the great painters: that of having put his hand to every kind of subject. His recent studies

G eorges Clemenceau *c.* 1900 (left); plan of the Orangerie (below); Monet's *Water-lilies* in the Orangerie *c.* 1930 (right).

Dissenting views

A seascape that could be turned upside down, for example, would be a bad painting. Turner himself, otherwise so daring in his luminous phantasms, never risked painting a *reversible* seascape, one

of the Thames are, at the decline of his energetic maturity, as beautiful and as spontaneous as the 'Hay-ricks' of seventeen years back. They are thrillingly truthful visions of fairy mists, where showers of silver and gold sparkle through rosy vapours; and at the same time Monet combines in this series the dream-landscapes of Turner with Monticelli's accumulation of precious stones. Thus interpreted by this intense faculty of synthesis, nature, simplified in detail and contemplated in its grand lines, becomes truly a living dream.

Camille Mauclair
The French Impressionists 1860–1900
1903

in which the sky could be taken for water and the water for sky. And if Monet the Impressionist has done this in his equivocal water-lily series, one can say that he has sought his penitence in sin; for never have Monet's *Water-lilies* been, nor will they ever be, held as a serious event in the history of art. Rather they will be viewed as a caprice which, though it pleases for a moment, fails otherwise in every way to gain admittance to the nobler archives of our memory. They are a brief diversion; they are intimately related with a purely decorative element, like the products of industrial art; they are akin to arabesques, tapestries, Faenza plates;

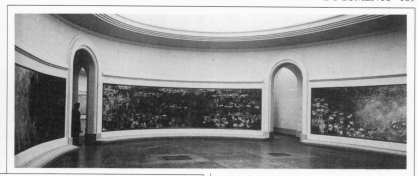

they are something, finally, that one sees without looking, grasps without thought, and forgets without remorse.

Eugenio d'Ors
La Vie de Goya, 1928

The work in which Monet freed himself from all vestige of tradition but lost his first freshness, is shown very lavishly in two special rooms containing panels intended by the master 'for eternity', which represent water-lilies on the pond of his property at Giverny. The result exudes a kind of misdirected superiority; and certainly admirers of Monet who have tolerated this have not served Monet's memory well.

No doubt there are certain qualities in the *Water-lilies*. Not everybody can do such things; if one examines these 'smeared expanses' with love, one sees in them the technical experimentation and sonority of Monet's palette. Nevertheless, what emptiness, what an obvious lack of understanding, what a strange and truly pitiful crowning is this, to the career of the painter of *Woman in Green* and *The Picnic*! What a shame that the demands of creative research should at such a moment have obliged the artist to betray his early investigations; what vanity can have enticed him into this realm of monumental decoration, when he was really not at all gifted in the field? And finally, how ironic that France, which in earlier days had airily permitted the snatching away of her glorious son's most wonderful masterpieces, should at last erect for his feeblest and most overrated work an entire temple, which more than anything else resembles the saloon deck of a transatlantic liner!

Alexandre Benois
on the Monet Exhibition
at the Orangerie, 1931
from *Alexandre Benois refléchit*, 1968

The *Water-lilies* at the Orangerie are a fully constructed work of art, and the

real lily pool is present not as model, but as master.... One may see to what degree the late work of Monet is absolutely a thing of the mind.

There are broad fringes of reeds and bankside rushes; woolly, vertical treetrunks in the second room; narrow vertical fringes of willow foliage; roughened surfaces of clouds that are the wrong way up, horizontal and more or less elongated, and rippling on the skin of the water; broad enveloping flourishes for water-lily leaves with blazing flecks for flowers. In short, we are faced with a complete system of coded signals.

The raising of the horizon, which was formerly such a feature of Monet's work, is now complete, for the sky and the distance no longer appear, save in their inverted form, and the water surface rises vertically all around us, as in a dream of flying or diving....

In the real-life pool at Giverny, the water would have turned the world topsy-turvy even had there been no flowers; but in Monet's work of art the flowers are the only figurative element.

Michel Butor
Art de France, 1963

It is unimaginable, that such huge, outsize canvases should have been fashioned out of such an insignificant little pool.

Jean-Paul Riopelle
quoted by Jean-Dominique Rey
in *Galerie-Jardin des Arts*
July–August 1974

Monet dedicated his final years to his lyrical series of *Water-lilies*. I was surprised to find myself taking off my hat to the man. When a reality provokes so decisive a reaction, there can be no denying it: the work is strong and noble. Despite his apparent superficiality,

Monet, like Matisse, achieves results of as great consequence as certain much more severe works. The chapel-like presentation and the aquarium light contribute to this powerful impression, but all the same, Monet himself has a great deal to do with it.

Amédée Ozenfant
entry for 27 June 1931
Mémoires 1886–1962, 1968

We may dream of Claude Monet moving towards the use of broad, clear expanses like Veronese

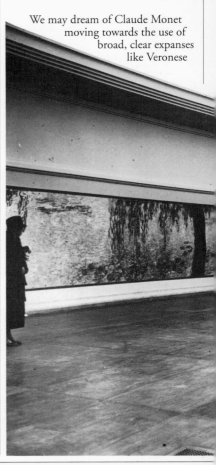

or Tiepolo. Let us dream no more, and consider his supreme work, the *Water-lilies*. Despite their monumental dimensions, the *Water-lilies* show none of the characteristics of great Flemish and Venetian decorative art. Monet's mental disposition here seems to me to have been that of a great easel painter, who has decided to endow his vision with a field broad enough to encompass the whole world. Here a mirror of water suffices for our identification with the universe. A cosmic vision, I would prefer to say, if that word had not been hijacked recently, and used to describe just about anyone and anything. Thus Michelangelo, a creator of solitary, unique figures, had to await the day when the Vatican would allow him to take wing, to show his power. For this reason it gives me profound delight to say of the Orangerie that it is truly the Sistine Chapel of Impressionism. A deserted place in the heart of Paris, it lends an element of sacred inaccessibility to the masterpiece it contains; which is one of the supreme achievements of French genius.

André Masson
'Monet, le Fondateur'
Verve, vol. VII, nos. 27
and 28, 1952

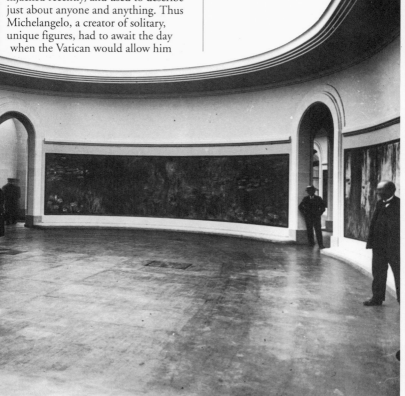

FURTHER READING

CATALOGUE OF THE ARTIST'S WORK
Wildenstein, Daniel, et al., *Claude Monet, Biographie et Catalogue Raisonné*, 4 vols., 1974–85; fifth volume in preparation. This important work, on which this book is largely based, includes Monet's published correspondence.

GENERAL TITLES
Gordon, Robert, and Andrew Forge, *Claude Monet*, 1984
Herbert, Robert L., *Impressionism: Art, Leisure and Parisian Society*, 1988
Hoog, Michel, *Les Nymphéas de Claude Monet au Musée de l'Orangerie*, 1984 and 1987
House, John, *Monet*, 1977
——, *Monet: Nature into Art*, 1986
Joyes, Claire, *Claude Monet: Life at Giverny*, 1985
Kendall, Richard (ed.), *Monet by Himself*, 1989
Rewald, John, *The History of Impressionism*, 4th revised edition, 1973
Seitz, William C., *Monet*, 1984
Spate, Virginia, *The Colour of Time: Claude Monet*, 1992
Tucker, Paul Hayes, *Monet at Argenteuil*, 1982
Wildenstein, Daniel, *Monet's Years at Giverny: Beyond Impressionism*, 1978

EXHIBITION CATALOGUES
Hommage à Monet, Grand Palais, Paris, 1980
Monet in Holland, Rijksmuseum Vincent van Gogh, Amsterdam, 1986
Monet in London, High Museum of Art, Atlanta, 1988–9
Monet in the Nineties, The Series Paintings, Museum of Fine Arts, Boston; Art Institute of Chicago; Royal Academy of Arts, London, 1990
Monet–Rodin, Centenaire de l'Exposition de 1889, Musée Rodin, Paris, 1989–90
Monet's Years at Giverny: Beyond Impressionism, Metropolitan Museum of Art, New York, 1978

MUSEUMS

Nearly two thousand paintings by Monet have been identified; many are in museums the world over.

In France, there are about thirty paintings by the artist in provincial museums. In Paris, apart from the Petit Palais and the Musée Rodin, which contain a few works by Monet, three museums are very rich in his paintings: the Musée Marmottan has a collection derived from the Donop de Monchy Bequest and the bequest of Michel Monet, the painter's second son; the Musée d'Orsay possesses about sixty paintings by Monet; and the Orangerie in the Tuileries Gardens includes two rooms dedicated to the *Water-lilies*. Finally, the Musée Claude Monet at Giverny, though it contains no original work by the painter, has been open to the public since 1980. The gardens, greenhouses, water-lily pool, house and studios are all of particular interest to visitors, being closely linked to Monet's work in his last years.

There are fine examples of Monet's work in museums throughout the United States of America, including the Museum of Fine Arts, Boston; the Art Institute of Chicago; the Los Angeles County Museum of Art; the Metropolitan Museum of Art, New York; the Philadelphia Museum of Art; and the National Gallery of Art, Washington, D.C.

In Britain, collections include those of the Fitzwilliam Museum, Cambridge; the National Museum of Wales, Cardiff; the Courtauld Institute Galleries, London; and the National Gallery, London.

LIST OF ILLUSTRATIONS

All works are by Claude Monet except where stated otherwise. The following abbreviations have been used: *a* above; *b* below; *c* centre; *l* left; *r* right; Bibl. Nat. Bibliothèque Nationale

CHAPTER 7

DOCUMENTS

PHOTO CREDITS

All Rights Reserved 16*a*, 17*a*, 17*b*, 18*b*, 38*a*, 38–9*a*, 50*a*, 71*a*, 75*r*, 88*a*, 94*a*, 94*bl*, 99*b*, 114–5*a*. A.P.N., Paris 21*a*, 36*ar*, 57*a*. Archiv für Kunst und Geschichte, Berlin 115*ar*. Archives Durand-Ruel, Paris 78*b*, 79*a*, 79*b*, 80–1*b*, 83, 101, 116–7, 124*l*, 126–7. Archives Nationales, Paris 164–5. Archives Tallandier, Paris 65*a*. Artephot/Bridgeman 74*a*. Artephot/Held 44*a*, 44*bl*. Art Institute of Chicago 12, 24–5*b*, 46–7, 47*b*, 47*c*, 81, 102, 103*l*, 104*a*, 104*b*, 105*a*, 105*b*, 106–7. Bildarchiv Preussicher Kulturbesitz, Berlin 55*a*. Bridgeman Art Gallery, London 22–3, 23*r*, 37, 123*a*. Bridgestone Museum of Art, Ishibashi Foundation, Tokyo 120. Bulloz, Paris 92, 158, 161. Centre Georges Pompidou, Musée National d'Art Moderne, Kandinsky Foundation, Paris 139. J.-L. Charmet, Paris 35, 38–9*b*, 67, 138, 149. Edimedia, Paris 90*l* and *r*, 136. Ellebé, Rouen 66. Fogg Art Museum, Harvard University Art Museums, Cambridge, Mass. 61*al*. Galerie Bernheim-Jeune, Paris 53, 118*b*. Giraudon/Lauros 117. Giraudon/Musée des Beaux-Arts du Havre 115*b*. Giraudon/Musée du Petit Palais, Paris 75*l*. L'Illustration/Sygma, Paris 6, 8. © Bruno Jarret by ADAGP and © Musée Rodin, Paris 88–9. Kunsthaus, Zurich, Association des amis de l'art zurichois 80. Metropolitan Museum of Art, New York 24, 26–7, 30*a*, 42*a*, 59, 118–9. Musée d'Art Moderne de Saint-Etienne/Yves Bresson 123*b*. Musée des Beaux-Arts de Lyon 77, 78*a*. Musée municipal de Honfleur 16*bl*. Musée Rodin, Paris 94–5*b*. Musée d'Unterlinden/ O. Zimmermann, Colmar 93*b*. Museum of Fine Arts, Boston 58, 108*b*, 109*b*. National Gallery of Art, Washington, D.C. 42*bl*, 76, 99*ar*. National Museum of Wales, Cardiff 113*r*. Nelson Atkins Museum of Art, Kansas City 56. Philadelphia Museum of Art 33*a*, 49, 110–1. Philippe Piguet Collection 154. Private collection, France 60, 100. Private collection, New York 91*b*. Réunion des Musées Nationaux, Paris front cover, spine, 1*al*, 1*bl*, 1*br*, 2, 3, 4, 5, 9, 11, 18*a*, 19, 20*r*, 21*b*, 22, 25*a*, 28–9, 32*a*, 32–3, 34, 36*al*, 36*b*, 40–1, 44–5, 52, 55*b*, 57*b*, 62–3, 64–5, 68, 69*a*, 70*a*, 70–1, 72, 73, 82, 95*a*, 97, 98, 99*al*, 108*a*, 109*a*, 112*l*, 113*l*, 116, 122*l*, 122*r*, 124*r*, 128 recto and verso, 139, 152. Roger-Viollet 132. Roger-Viollet/Cap 68–9*b*. Roger-Viollet/Harlingue 160, 162, 165, 166–7. Roger-Viollet/ND 88*b*. Santa Barbara Museum of Art 84*ar*, 85*a*, 85*br*. Sipa Archives, Paris 30–1. Sirot/Angel Collection, Paris 14–5*a*, 54, 64*l*, 74*b*, 84*al*, 85*bl*, 91*a*, 121, 133, 134, 135, 144, 146, 148, 164*al*. Statens Konstmuseet, Stockholm 30*b*. Sterling and Francine Clark Art Institute, Williamstown 86*a* and *b*. Studio Lourmel 77, Jean-Michel Routhier back cover, 1*ar*, 7, 14*a*, 14–5*b*, 15*r*, 20–1, 39, 42*br*, 43*a*, 43*b*, 61*ar*, 61*b*, 84–5*b*, 86–7*c*, 93*a*, 96*a*, 96*b*, 103*r*, 112*r*, 114–5, 118*a*, 124–5*l*, 125*r*, 130. Jean-Marie Toulgouat Collection 13, 156*l*, 156–7, 159. Wadsworth Atheneum, Hartford, Conn. 47*ar*.

ACKNOWLEDGMENTS

The author is especially grateful to Marianne Delafond (Musée Marmottan), Caroline Durand-Ruel Godfroy (Archives Durand-Ruel), Françoise Heilbrun (Musée d'Orsay), Jacqueline Henry (Documentation), Michel Hoog (Musée de l'Orangerie), Philippe Piguet, Claire Joyes and Jean-Marie Toulgouat (archive photographs), the Wildenstein Foundation, the Photographic Service of the Réunion des Musées Nationaux and Gérard Patin, for their help in the preparation of this volume.

The publishers wish to thank the Bernheim-Jeune Gallery and the Durand-Ruel Gallery, Paris, and Claire Joyes, Jean-Marie Toulgouat, and Philippe Piguet for their kind assistance.

Sylvie Patin
worked at the Jeu de Paume and the
Musée de l'Orangerie in Paris before being appointed
curator of paintings at the Musée d'Orsay. She has helped to
organize several exhibitions, including 'Homage to Monet'
(1980), 'Impressionism and the French Landscape' (1985)
at the Grand Palais and 'Monet–Rodin' (1989) at the
Musée Rodin in Paris. Her recent publications include
A la campagne (1986) and *Jardins d'hier et
d'aujourd'hui* (1991).

For Louis-Gabriel and Sophie

Translated from the French by Anthony Roberts

First published in the United Kingdom in 1993
by Thames & Hudson Ltd
181A High Holborn
London WC1V 7QX

© Gallimard/Réunion des Musées Nationaux 1991

English translation © Thames & Hudson Ltd, London,
and Harry N. Abrams Inc., New York, 1993

Reprinted 1995, 1997, 1998, 1999, 2002, 2005

British Library Cataloguing-in-Publication Data
A catalogue record for this book is available from the
British Library

ISBN-13 978-0-500-30030-5
ISBN-10 0-500-30030-5

Printed and bound in Italy
by Editoriale Lloyd, Trieste